INTO THE LIGHT

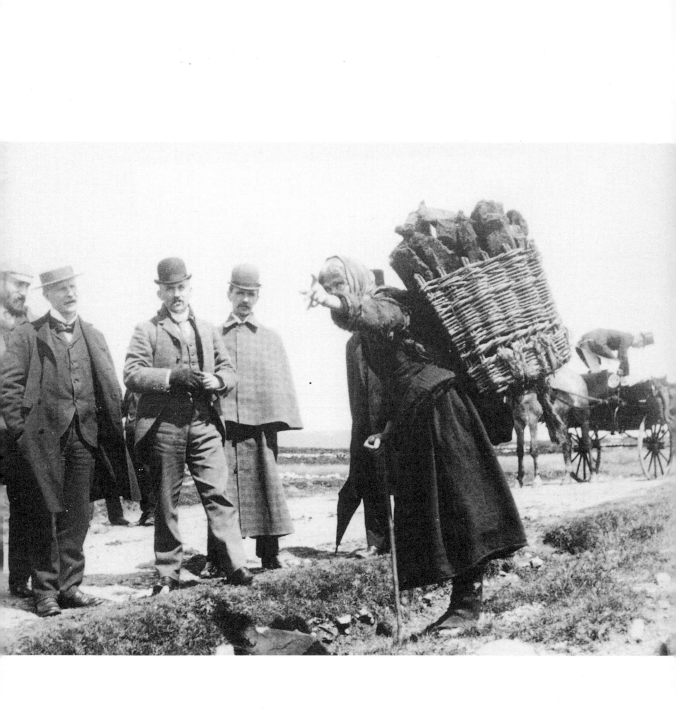

Into the Light

*An Illustrated Guide
to the Photograph Collections in the National Library of Ireland*

SARAH ROUSE

NATIONAL LIBRARY OF IRELAND
DUBLIN
1998

Published by the National Library of Ireland, 1998
© National Library of Ireland, 1998

British Library Cataloguing in Publication information available.

ISBN 0 907328 29 6

Photography by Eugene Hogan
Designed by Jarlath Hayes
Origination by Accu-Plate
Printed by ßetaprint

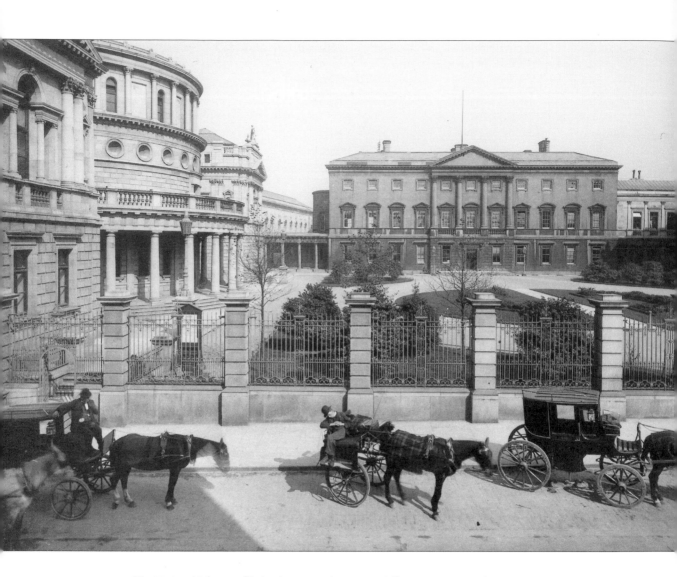

The National Library of Ireland, *ca.*1890. (Lawrence Collection. Imp. 4,208)

ACKNOWLEDGMENTS

The research and writing of this guide was undertaken on a Fulbright Research Scholarship, September 1996-February 1997, at the National Library of Ireland, Dublin. My greatest thanks, as well as much of the credit for the work, are due to the National Library Photographic Archive's Gráinne MacLochlainn. Without her help in focusing the work and overseeing production, plus her knowledge of the Library, sound judgement and boundless energy, not to mention irrepressible good humour, this guide would not have been completed. In addition, my thanks to: Dr. Patricia Donlon, former Director of the National Library of Ireland, for her wholehearted and energetic support of the project; David McLoughlin, for his consistent generosity in providing detailed information and reference assistance; as well as patience and a rare sense of humour. Also at the National Library, my sincere appreciation especially to Brian McKenna, for his unstinting support and for providing me a perfect place to work; Dónall O'Luanaigh, for giving me an open door to his prodigious memory and experience; Dr. Eílís Ní Dhuibhne, for her valuable early support of my project, her work with the albums, and descriptions of collections in *Treasures from the National Library of Ireland*; Dr. Noel Kissane, for his substantial contribution to the clear writing of the guide, as well as his fine publications that inspired this one; Eugene Hogan for his expert help with reproducing the photographs; Robert Monks for sharing his personal collection of documentation and his enthusiasm for the photographic medium; Sandra McDermott for her steady hand and technical help; and for their innumerable kindnesses and helpful acts, thanks to Joanna Finnegan, Louise Kavanagh, Colette O'Daly, Ross Hackett, Paul Jones, John Brazil, John O'Leary, Elizabeth Kirwan, Inez Fletcher, Gerry Long, Angela Kelly, Colette O'Flaherty, Matthew Cains, Olive Murphy, Tom Desmond, Sylvia Lynam, Mary Hurley, Teresa Biggins, James Fleming, and Kevin Browne.

Appreciation is due others who helped me begin, continue, and extend the project: Kevin Rockett, Kate Buford, Patricia Butler, Norma R. Jessop, Anne Fuller, Michael FitzGerald, Joe Brennan, Brian Sinclair, Vincent Virga, and John McBratney. Thanks too to members of the Ireland-U.S. Commission for Educational Exchange not previously thanked: Professor Brian Farrell, Dr. Yvonne Scannell, Professor Georóid O'Tuarthaigh, Ambassador Jean Kennedy Smith, Mrs. Madelyn Spirnak, Dr. Patricia Walsh, and Brian P. Burns as well as Ms. Jean Rylands. My especial thanks to Jarlath Hayes for his handsome and practical book design.

I am also grateful to my colleagues at the Library of Congress in Washington, D.C., who helped prepare me for the project, and who kept my chair for me while I was absent for six months, especially Elisabeth Betz Parker, Jeanne Korda, Helena Zinkham, Dr. Stephen Ostrow, and Helen Arden Alexander. Thanks to colleagues and fellow Fulbrighters Judith Reid and Dick Nanto for their encouragement. My appreciation also to those who provided recommendations for me to receive the scholarship: Dr. Karen Newman, Brown University; Dr. James Todd, University of Montana; Barbara Orbach Natanson, Library of Congress Prints and Photographs Division; and Steven Hensen, Duke University. My boundless thanks to my family for their unflagging encouragement. And to Patrick, my Irish connection, whose idea it was.

INTRODUCTION

This guide describes, indexes, and illustrates the nearly 90 collections of almost 300,000 photographs in the holdings of the National Library of Ireland's Photographic Archive. It extends the information provided by previous National Library publications, *Ex Camera 1860-1960* (1990) and *Treasures from the National Library of Ireland* (1994). Images described in this guide range from the mid-1840s to 1996. Most are topographical views, documentary images, and portraits. Their value is informational, artifactual, and aesthetic. Almost all depict Irish subjects or persons, and were taken by Irish photographers. As a group, the images provide a sweeping visual history of Ireland, and each collection tells its own story. Individually, the photographs give rich evidence of places, events, and people who have shaped the nation. For browsers, the guide will spark ideas; focused researchers can find specific collections useful in their work.

RESEARCH VALUE OF PHOTOGRAPHS:
Since the mid-1950s, photographs have steadily gained recognition as primary research materials. No longer sought simply by book publishers as illustrations to enliven a printed text, photographs are increasingly valued as historical documents, revealing useful and detailed evidence to the visually literate researcher. Early photographers and 19th century technical processes intrigue historians. Biographers, curators, and filmmakers can use photographs to illuminate the past. As cultural artifacts and works of art, photographs command the attention of collectors and exhibitors. Now, these long-hidden but powerful images are being brought into the light.

Repositories have begun to actively encourage patrons' interest in their photographic holdings by creating collection guides, reference aids, online catalogues and digital surrogates. Acquisitions, often casually accumulated previously, are now carefully targeted to build on existing strengths, fill in gaps, and anticipate research demands. Conservation resources are being channelled into protecting historical photographs. Interpretive exhibitions and controlled marketing by libraries and archives bring photographs to a wider public.

NATIONAL LIBRARY OF IRELAND'S PHOTOGRAPH COLLECTION:
The National Library's Photographic Archive contains the largest collection of Irish photographs in the world, nearly 300,000 images. Although the Library's textual holdings have long been its greatest asset, its photographic collections are now understood to be an important part of the nation's intellectual legacy. Now a reality, the National Photographic Archive will manage and preserve these collections under optimum conditions, to ensure their survival as part of Ireland's cultural heritage.

Founded in the 1870s when literacy and publishing were increasing, the

National Library of Ireland readily developed its holdings of books, newspapers, periodicals, maps, and manuscripts. By the turn of the century, photographs as documentation and personal expression were accumulating in commercial and private hands. Slowly, the Library began adding photographs to its holdings. Its 1943 acquisition of the magnificent William Lawrence Collection was a watershed event. Since then, generous donations and judicious purchases have developed the collections to their present size and breadth. As with all the Library's holdings, the photograph collections are acquired, preserved, and served to the public in support of the Library's mission to provide items of Irish interest for the nation and beyond.

THE COLLECTIONS AS HISTORY:
The collections fall into a broad range of overlapping areas including early photography, topographical views, portraits, amateur snapshots, the arts, family photographs, industry and transport, regional collections, and modern documentary images.

While Ireland's earliest images were probably from 'Professor' Gluckman's cen-

Mrs. M.J.Murphy and children in pony trap, Tramore, Co.Waterford. (Poole Collection, Poole Imp. 220)

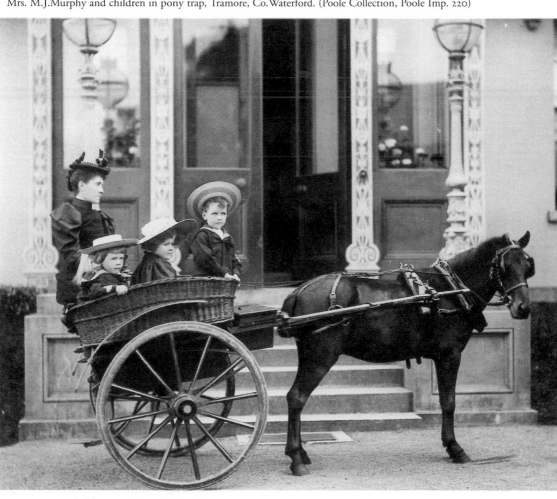

tral Dublin daguerreotype studio opened in October 1841 at the 'Rotundo Assembly Rooms' (renamed the Rotunda), most of the Library's oldest holdings are from well-to-do women and men with time for hobbies—and for long waits for exposure and printing. Notable photographs in this category are mid-1850s images by Louisa Tenison and Edward King Tenison, and those in the Dillon family's Clonbrock Collection, showing gracious daily life on orderly estates. Early "photogenic drawings" found in Englishman William Henry Fox Talbot's *Pencil of Nature* are also in the collections.

Mid-19th century experimentation and domestic subjects soon gave way to more practical uses. By the latter part of the century amateur historians and antiquaries abandoned their pen-and-ink and watercolours for the more exact photographic recording of architecture and historic sites. Such photographs, direct descendants of topographical prints and drawings of earlier times well-represented in the Library's Prints and Drawings Department, can be found in the Thomas J. Westropp Antiquities Albums and the later Kilkenny Architectural Photograph Collection, among others.

As in other countries, commerce was a driving force in the growth of photography in Ireland. From the 1850s, photographers created peaceful landscape views for photographic prints and later postcards purchased by souvenir-hungry tourists and armchair travellers. The National Library has thousands of such images, many as original glass negatives, notably in the Lawrence Collection, from all parts of Ireland. The Lawrence Collection's reputation is for romanticised topographical views, most taken by skilled photographer Robert French. It is important to note that numerous detailed images of Dublin, people in various locales, and significant events such as evictions in the 1880s, are also found in the Lawrence Collection. Lawrence's tourist views are supplemented by the later Eason and Valentine collections, with Valentine's depicting some specific events, as well.

Experimental photography is reflected in the collections, notably the John Joly colour slides. John Joly was a relative of Jasper Robert Joly who was instrumental in founding the National Library of Ireland. Other applications of photography, such as wide-angle and three-dimensional formats, can be found in the unusual Panoramic Albums that record Ireland's coastal locales, and in the entertaining and informative 19th century stereoscopic views in the Stereo Pairs and Edward Chandler collections.

As early as the 1880s, roll film and easy-to-operate cameras were beginning to be manufactured for amateur photographers. By the early 1910s, tireless hobbyists recorded parades, tourist destinations, and personal keepsake images. The snapshot aesthetic of unposed and instantaneous images overtook the earlier frozen-in-time static views. Amateur photographer Dorothy Stokes thoroughly recorded her travels around Ireland and active social life in the 1920s and 1930s; her many personal albums reside in the archive.

Prior to the 1890s, woodcuts and engravings in illustrated publications helped visualise news and personalities. After that time, developments in printing processes enabled photographic images to be reproduced in newspapers and books.

Journalistic photography could help sell the news, especially to the average working man and woman. While no photographs are known of the 1845-1849 famine, photographs of highly-charged political events and the people involved in them in the 1880s, 1916-1917, and 1918-1923 can be found in the Coolgreany, Wynne, and Fitzelle Albums, and the Keogh and W.D. Hogan Collections. Many of these images were utilized by mass communication media.

Complementing the commercial images, Thomas Westropp's Easter Rising Album provides his personal record of Dublin after the Easter Rising. Record photographs of ethnographic research can be found in Browne's 1895 *Ethnography of the Mullet* volume. Official record images by the Congested Districts Board reveal rural life in several counties in the west around 1906.

Several photograph collections provide a visual counterpoint to the Library's extensive holdings on theatre, literature, and the arts. Scenes from Abbey Theatre productions, the Wexford Festival (Hickey Collection), and artist Harry Kernoff and R.H.A. selection committees show the creative side of 20th-century Ireland. Poet Patrick Kavanagh is depicted (Wiltshire Collection), at home in Co. Monaghan and in Dublin on Bloomsday 1954.

Throughout the Library's history, prominent individuals have generously donated personal papers to the Library. Along with letters and documents come family photographs often spanning a long period. These personal collections provide a sweeping visual document of a person's life and times, ideal in biographical research. The Hanna Sheehy Skeffington and Richard Mulcahy collections exemplify this valuable genre.

While 19th-century industry in the Republic was slight, 20th-century industry and a related field—transport—are important subject areas. The James P. O'Dea Collection of railroad-related images, and to a lesser extent because much smaller, the Boyne Viaduct and Dripsey Woolen Mills albums provide visual evidence. Related to transport is the Morgan Aerial Photograph Collection, documenting 1950s Ireland from the cockpit of a twin-engine Piper Apache.

As in most photographic archives, portraits are a large part of the holdings. Many are from 19th-century photographers on Dublin's "photographic mile" of Grafton, Westmoreland, and (then) Sackville streets. Images span from early daguerreotypes, to later (and cheaper) carte-de-visite portraits, and lastly to modern outdoor portraits of school groups, office staff groups, and social groups. The Edward Chandler Collection of cartes-de-visite and the Keogh Photograph Collection, not to mention several massive collections of negatives in the Poole and Wynne collections, form an important core of the portrait holdings. These materials, especially when accompanied by photographers' record books, can be a useful source for biographers, genealogists, and regional historians.

Regional collections, some generated by commercial firms operating in an area over a long period, balance the strong urban coverage. The Poole (Waterford) and Wynne (Castlebar) collections mentioned above are rich records of their regions' life and people, spanning as they do several decades. The much smaller personal collection of Pádraig Tyers shows life in Co. Kerry. Other small groups of region-

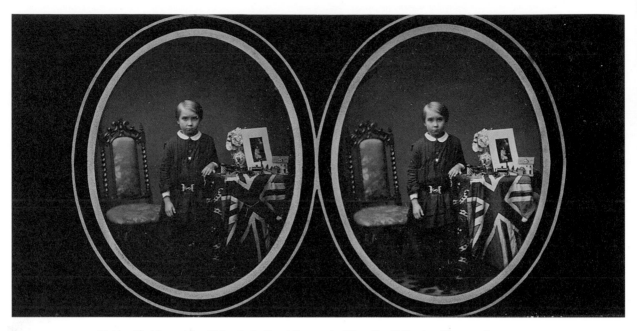

Unidentified boy with a Union Jack. Cased Stereopair. (Chandler Collection. Trans. 126)

al interest are the Levingston (Galway), Spillane (Castletownbere), and Tempest (Dundalk) collections.

The collections provide coverage right up to the present. Modern Ireland is portrayed in stark documentary photographs: mid-century Dublin has been photographed by Elinor Wiltshire, Belfast in the 1980s by Brian Hughes, and Tory Island in the 1980s by Dorothy Therman. In addition, the Lawrence Photographic Project and the Our Own Place Photographic Project bring the collections full circle, with their documenting in the 1990s of the same locales as did the William Lawrence Collection a century before.

THE FUTURE:

The National Library's Photographic Archive is being developed carefully to provide broad coverage—chronologically, geographically, and in subject matter—of Irish interest photographs, commercial and amateur, documentary and artistic, 19th and 20th centuries. Public access to materials is also growing rapidly, with automated cataloguing data available on an online database. Imaging projects are currently underway, to provide researchers with surrogate images for easy viewing. Over time, the online catalogue data and digital images will cover items not yet listed in detail, as well as supersede existing finding lists and reference copies.

THE GUIDE:

The Purpose of the Guide: This guide was produced to help researchers, including scholars and historians, casual users, as well as staff of the National Library. It is a first step in providing published and specific information about the Library's hold-

ings of photographic negatives, prints, and slides. Surveying the photograph collections, this guide describes, indexes, and illustrates 88 of the over 100 discrete collections and groupings in the Library's custody December 1995. Since that time, other collections will have come to light and yet others will have been acquired. It is important to note that many of the collections have varying degrees of accessibility; in particular the original negatives and slides are not accessible to researchers. Over time, increased access will be offered. For many collections, the Library supplements this guide with surrogate images, online information, detailed lists, catalogues, indexes, finding guides, and publications, as noted in the entries.

Scope of the Guide. The guide provides a descriptive entry for most collections in the Photographic Archive. A collection is generally understood to be a group of items maintained as a unit. Most collections were acquired as units; others have been assembled as files internal to the archive. The guide does include summary information for a unit comprising various small negative and slide collections and a unit of various albums. In addition, the copy negative and transparencies generated by the Library are considered a unit, as are the many miscellaneous images sorted and stored in subject categories. The guide does not intend to describe all photographic materials throughout the Library. Many photographs properly reside in the custody of the Manuscripts Department. A few notable Manuscript Department photograph collections, such as that of Dr. John de Courcy Ireland, are described here, but this practice has been extremely selective. Also outside the scope of this guide are photographs mounted on pages of printed books in the general or rare book collections. A few collections in the Photographic Archive have been excluded from the guide as at the time of writing they were unable to be surveyed. These include, among others, the Dixon, Griffith, and Pearse collections.

The guide was prepared in three stages. The first was to establish, in consultation with National Library staff, what information was to be included in the publication. Generally, entries include standard elements of archival description established by the profession. The second stage was to locate and inspect the collections, and then gather information. This stage also included research in various reference sources, principally those in the collections of the National Library itself. The last stage was the writing of descriptive entries, drafts of which were reviewed and amended by knowledgeable staff in the Photographic Archive and other departments of the National Library. The guide is a research aid and not intended to be a substitute for studying the collections themselves. Certainly, as the first overall guide to the photograph collections, it will have shortcomings. Suggestions from users are very welcome, and will help subsequent revisions to this work.

SARAH ROUSE
June 1998

HOW TO USE THIS GUIDE:

Collection descriptions are arranged in alphabetical order by collection name, most commonly the subject, surname of donor or creator, or corporate name.

For example: Alice Stopford Green Collection is under "G"
Hinde Postcard Collection is under "H"
Panoramic Albums is under "P"

DESCRIPTIONS INCLUDE:

A collection name based on historical practice, the donor's surname, the subject's name, the creator's name, or characteristics of the collection. All collection names are in the index.

A date span for items in the collection; bulk dates are also provided if applicable.

(Note: Dates are the year of depiction, not the date of printing. For copy prints, original dates are given, along with the designation "copy print".)

The number and type of items, such as: 105 photographic prints, 8 glass negatives, 13 albums. Specific print processes, such as "albumen prints", were included when this information was certain. Dimensions have been provided for some materials. The glossary further explains technical terms.

Historical information, as available, about the photographer, collector, and circumstances of the photographs' creation. This information was researched in sources including contemporaneous publications or manuscripts, reference works, unpublished documents, official reports, and information from specialists at the National Library.

Description of the materials, miscellaneous details, and examples of items characteristic of the collection.

Access for the researcher to the materials. A number of collections have some degree of access, including surrogate images (reference prints, photocopies, microfilm, or contact prints, and increasingly, digital images), printed indexes, card catalogue entries, or automated catalogue records. The National Library's ongoing programme to catalogue its photographs will ensure a growing online database of information.

Restrictions on reproduction or use. Consult staff for details.

Related publications, exhibitions, or collections. These will be cited as appropriate. Information will not attempt to be comprehensive.

Provenance or source information is provided, when available.

A sample image and/or relevant graphic work accompanies the collection description. In the case of the largest collections, several images may represent the material. Similarly, for small collections, sometimes no image was selected. A short caption and the Library's reproduction number is provided for each image.

THE APPENDICES:

Appendix A: Collections by decade covered. This listing groups collections covering any decade, should one wish to focus on images from a particular period

or around the time of a specific historical event. Collection names are shortened. Larger collections (over 1000 images) are in boldface.

Appendix B: Collections by size. Collections are named beginning with the largest—the Poole Collection—to the smallest. Almost half the Library's collections, or 37, contain fewer than 100 items.

THE INDEX:

The index lists subjects, place names, personal names (as appropriate) and events, referring to the page number of the entry. Indexed names also include those of the collections themselves, and alternative names. Because of the sheer volume of entries it would entail, the index is not item-specific; for example, a single image of Brendan Behan in a collection of over 300 images of various notable people would most likely not be indexed under Behan, but under a more general term, such as Literary figures. However, if a collection held a significant number of images of an individual, then that individual would be indexed.

PUBLIC SERVICE:

The National Library's mission is to collect and preserve materials of Irish interest and to make them accessible to the public. The National Library is open, free of charge, to all who want to use it. Persons wishing to use the collections must first be interviewed to establish their identity and to ensure that the items they require are actually available in the Library, and not more readily available in a local public library. The applicant is then given a Reader's Ticket to be displayed each day upon entry to the Library.

For the Photographic Archive as for Manuscripts and other rare and unique items, a special Reader's Ticket must be obtained. The reading room for photographic materials is open by appointment, and accessible materials require personal application before viewing. Staff will provide reference service as available. The guide describes the numerous manual and online catalogues and indexes that exist for certain collections. Readers' care in handling even surrogate materials is expected. For more information please contact:

National Library of Ireland
Kildare Street,
Dublin 2,
Ireland.

or
National Photographic Archive
Meeting House Square,
Temple Bar,
Dublin 2,
Ireland.

Dublin's Abbey Theatre was founded in 1904. It combined a national tradition of dramatic professionalism, in the form of Frank and William Fay's National Dramatic Company, with a surging interest in Irish literature, specifically W.B. Yeats and Lady Gregory's Irish Literary Theatre Society. The Abbey's Irish National Theatre Company operated on private funds until 1910, and thereafter was self-supporting; some government support of the Abbey began in 1924. By the mid-'40s, the Abbey had produced over 400 plays, most written specifically for it. When the original theatre was burned in 1951, the company continued, and a new theatre was built in Lower Abbey Street in 1966. The Abbey's directors and actors are respected worldwide, and it remains a dynamic institution.

This collection comprises black-and-white publicity photographs from plays by the Abbey, mostly from the 1940s. Most are mounted on display boards. The materials also include a group portrait *ca.* 1965 of the Abbey Company at playwright John Millington Synge's cottage on Inishmaan. Plays depicted include: "The Well of the Saints", "The Cursing Fields" (1942), "Juno and the 'Paycock'", "The O'Cuddy" (1943), "Damer's Gold", "The Canavans", "The Moon in the Yellow River" (1931), "The Whip Hand" (1942), "The Fort Field" (1942), "Killycreggs in Twilight" (1937), and others. Actors depicted include: May Craig, Arthur Shields, Barry Fitzgerald, Maureen Delany, Fred Johnson, Cyril Cusack, Shelagh Richards, and others. Most images were taken by Studio One, and "Mooney;" also, "P.C.," Colm O'Laoghaire, John Sarsfield, Peter Dorney, and James G. Maguire.

■ **Abbey Theatre Photograph Collection**

1912–1969; bulk, 1930–1950
ca. 150 photographic prints (mounted on display boards)

ACCESS:
Photocopies of some photographs are available as a reference aid. Otherwise, access is by personal application.

RELATED COLLECTIONS:
Material on the Abbey Theatre is held at the National Library, notably the Prints and Drawings, Manuscripts, and Printed Books Departments, as well as in the Frank G. Fay Photograph Collection.

PROVENANCE:
Gift of the Abbey Theatre; 1975-1984.

RESTRICTIONS:
Commercial photographs may have copyright restrictions.

The Irish National Theatre Society at the Abbey Street Theatre

Above:
Appearing on the Abbey programmes for many years was this emblem depicting Queen Maeve and an Irish wolfhound. The woodcut was by Elinor Monsell. (R. 21,728)

Left:
May Craig and Brid Ni Loingsigh in the Abbey's March 1942 production of "The Cursing Fields" by Andrew Ganley. (Abbey Theatre Photograph Collection. R. 27,858)

■ **Samuel Lee Anderson Album**

1865-1871
1 album : 204 photographic
prints

ACCESS:
*Album is held in the Manuscripts
Department.*

RELATED COLLECTIONS:
*Many similar photographs are held
in the National Archives, "Crime
Records 1866-1872: Description of
Fenian Suspects."*

PROVENANCE:
*From the papers of Samuel Lee
Anderson; 1954; MS 5957, acc.
1484.*

This album was assembled by Samuel Lee Anderson, who was involved in intelligence work in Dublin Castle for a period before and after the Fenian Rising in 1867 and was Crown Solicitor by 1882. The album is inscribed "Members of the Fenian Brotherhood, especially those who distinguished themselves by being convicted of treason-felony at the Special Commission of 1865-66, or arrested under the Habeas Corpus Suspension Act, 1866."

Many of the images are portraits of people in prison. Sitters are identified with names handwritten on the album page beneath the photograph. Sitters include: John Seery, Patrick Dunne, and Thomas Daly, all lodged in Kilmainham Jail, as Westmeath Ribbonmen, when the images were made. Ribbonmen were members of secret societies. Active in the 1820s, they pushed agrarian and political reforms, and some members were also Fenians. In 1870-1871, disturbances in Co. Westmeath provoked a law under which many of the men depicted in this album were detained.

This album has been previously called "Album of Fenian photographs."

Fenians associated with the Clerkenwell Explosion of December 1867 intended to free prisoners from the English Clerkenwell Prison, from this politically important album. (Samuel Lee Anderson Album. Trans. 177)

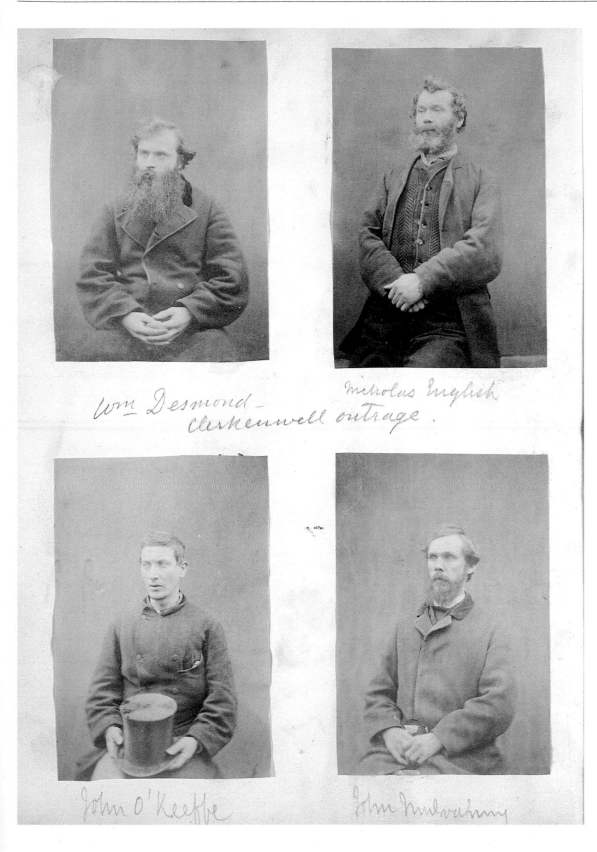

Wm Desmond — Nicholas English
Clerkenwell outrage.

John O'Keeffe John Mulvahny

■ **Blake-Forster Photograph Collection**

1860-1880
ca. 100 photographic prints
(copy prints)

ACCESS:
Copy prints are available for reference use.

RELATED MATERIAL:
Blake-Forster family records are indexed in Hayes, Catalogue of Manuscript Sources.

PROVENANCE:
Acquired November 1995. Copied from original material loaned by Kennys Bookshop, Galway, on behalf of the photographs' owner.

RESTRICTIONS:
Reproduction of images requires permission via Kennys Bookshop, Galway.

The Blake-Forster family, of Galway, generated this collection during photography's first burgeoning 1860-1880. Subjects are Galway buildings, castles, and ruins. The Library's prints are copy prints made from originals in a privately-owned album. Most prints have captions. These provide subject and location, for example: Menlo Castle, residence of Sir Valentine Blake; the Distillery, Nun's Island; Ross Abbey, Headford; Ardfry, Lord Wallscourt; the Shamble Barracks; Clogherty & Semple's extensive timber stores; and a portrait of Charles ffrench Blake-Forster of Galway (author of the historical novel *The Irish Chieftains; or, A Struggle for the Crown,* 1872).

■ **Boyne Viaduct Album**

1931-1932
1 album : 167 photographic prints, plus 8 loose photographic prints

ACCESS:
Album 51. Access to loose prints is by personal application.

PROVENANCE:
Purchased; 1984.

The railroad viaduct over the Boyne was constructed in 1855 for the Great Northern Railway. In the 1930s, the viaduct received much-needed renewal work. These photographs document that work. The black-and-white snapshots, by an unknown photographer, are arranged four per album page.

A detail of the reconstructed viaduct, 1932. (Boyne Viaduct Album. R. 28,706)

Incorporated in this bound version of Dr. Browne's scholarly paper on ethnography are original photographic prints documenting daily life in parts of the west coast of Ireland, in Erris, Co. Mayo. The pictures were taken to scientifically illustrate the paper which was being researched in August 1894. The subjects include: a woman spinning and carding, two views of a poitin stil (one with posed R.I.C. officers), a cattle fair in Belmullet, Binghamstown, the mail car, a building that had been used as a hedge school until 1892, interior of a cabin in Falmore, a family of ten outside their cabin in Develaun.

The photolithographs are from photographs taken by C.R. Browne and J.M. Browne. They are portraits of men of the same western area (Muingerena, Mullet; Iniskea; and Portacloy). The author, Charles R. Browne, M.D., M.R.I.A. read the paper before the Royal Irish Academy, February 25, 1895. Also bound into the volume is Browne's paper of November 1893 on the ethnography of Inishbofin and Inishark; it includes eight photomechanical plates but no photographic prints.

■ **Charles R. Browne's** *The Ethnography of The Mullet, Inishkea Islands and Portacloy, County Mayo*

1895
1 volume : 25 photographic prints and 22 photolithographs

ACCESS:
Album 187.

PROVENANCE:
Gift of D.G. Moore; 1956.

A man seated beside an ancient Ogham stone, 1895. (*Ethnography of the Mullet.* R 27,601)

■ Cardall Photograph Collection

1940-1960
ca. 5,000 photographic prints
(postcards) plus corresponding
film negatives

ACCESS:
*Index of postcards available for
reference. Postcards are arranged
alphabetically by town/city. Each
card bears a code number matching
it to its negative. Many cards are
captioned on the front; others have
pencilled captions on versos.*

RELATED COLLECTIONS:
*Eason, Lawrence, and Valentine
Photograph collections.*

PROVENANCE:
Purchased; 1972.

This collection comprises black-and-white
photographic postcards and their
negatives of views of 218 towns and cities
in the Republic of Ireland, taken in the
1940s and 1950s. Places depicted range
from Abbeyfeale, Drogheda, and Dublin,
to Malahide, Tralee, and Youghal. The
number of views for each place ranges
from 3 to 64, with the average being 18.
Besides conventional views, many of the
images are interesting street scenes, and
include people and automobiles,

advertising signs and shop fronts. Most cards provide a single view, while a few show several views arranged as a collage. There are a few "humorous" formats incorporating a photographic image framed by a a stereotyped "Irish" illustration. The photographer and year of each image is not known. The views do not provide as extensive coverage as the Lawrence Collection, but they document Ireland's urban life in the mid-20th century. The collection provides a good

follow-up to the earlier postcard views provided by the Eason and Valentine collections. Printing negatives (i.e., the negatives that include the postcard caption, not the camera negatives) are part of the collection.

The collection also includes approximately 150 unidentified film negatives, probably from a member of the Cardall family. Subjects include holiday snapshots, and family photographs.

Postcard from the 1950s showing a view of Drogheda, on the River Boyne. (Cardall Collection. 147 A (13/3))

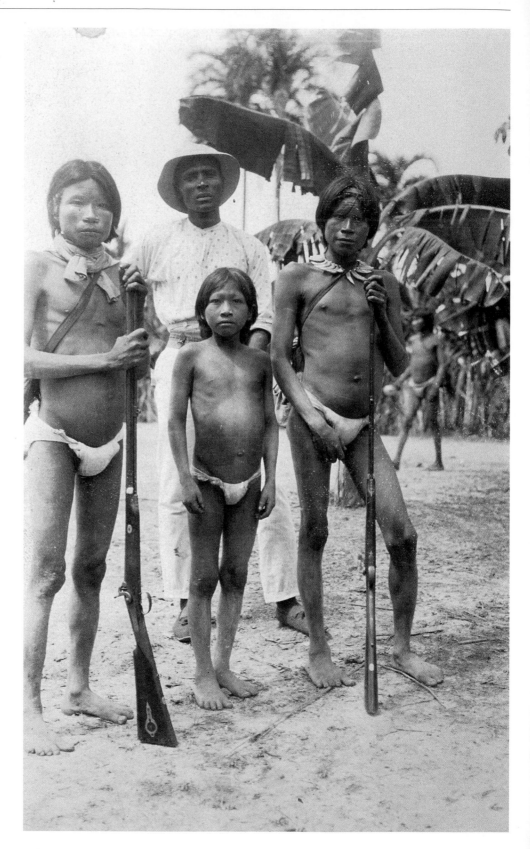

Roger Casement (1864-1916), a civil servant, explorer, human rights campaigner and Irish nationalist, was born in Sandycove, Dublin. He entered the British Foreign Service in 1892. He served in both the Congo and in the Putumayo River region, Peru, South America, where he witnessed atrocities against the native workers by the European companies. He wrote two reports highly critical of colonial cruelty earning him an international reputation as a humanitarian and, in 1911, a knighthood. Due to poor health he retired in 1913 by which time he was involved with the Irish Nationalist movement, culminating in his attempts to purchase arms. Upon his return to Ireland on a German U-boat, he was captured at Banna Strand during the week preceding the 1916 Rising and charged with high treason. Following his conviction and sentencing to death, many influential people lobbied for his reprieve until his diaries were circulated. These notorious Black Diaries suggested that he was a homosexual, and as a result support for his release diminished and he was hanged on 3 August 1916.

The collection of photographs comprises portraits of Casement and his family and a few informal group portraits taken during visits to the Donegal Gaeltacht. The bulk of material concerns his investigative work in the Congo and South America. A number of photographs depict the Putumayo tribespeople. There are also a few photographs of the interior of the Paris studio of Herbert Ward, an anthropologist friend from Casement's time in the Congo.

■ **Roger Casement Photograph Collection**

1890-1916
ca. **175 photographic prints**

ACCESS:
PC 97 Lot24. By personal application.

RELATED COLLECTIONS:
Alice Stopford Green Photograph Collection.

PROVENANCE:
From the papers of Sir Roger Casement, Manuscripts Department.

Members of the Putumayo tribe in South America, early 1900s. (Casement Collection. Trans. 176)

■ Lord Castletown Photograph
Collection

1860–1910
54 photographic prints, 35
negatives

ACCESS:
PC97 Lot20.

PROVENANCE:
*From the papers of Lord
Castletown; various MS accession
numbers.*

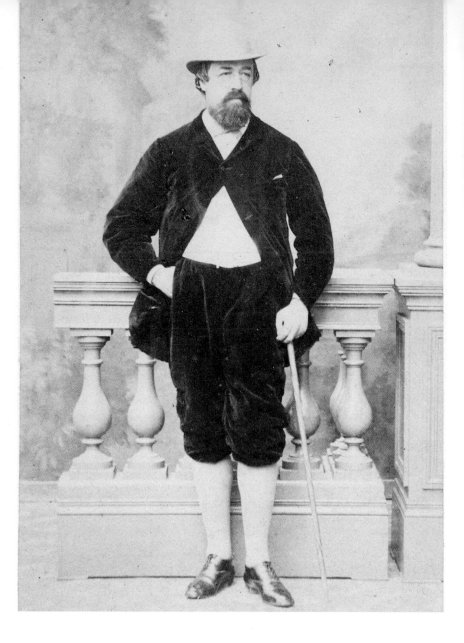

A carte-de-visite of Lord Castletown
of Upper Ossory, *ca.* 1875. (Lord
Castletown Collection. Trans. 90)

Lord Castletown of Upper Ossory,
Bernard Edward Barnaby FitzPatrick,
2nd Baron Castletown, was born in
1849. Taken from the National Library's
extensive Manuscripts Department
collection of papers of Lord Castletown,
this material is mainly portrait
photographs, including cartes-de-visite
and cabinet cards from London and
Dublin studios, and various scenes. The
collection is an example of a personal
collection in the late 1800s. Most sitters
are unidentified; those tentatively
identified include "Nell", Olivia

Fitzpatrick, Miss Winifred Hare, and
(possibly) Lord Castletown.

Also included in the collection are
views of people in gardens or at country
houses, for example, Doneraile Court,
ca. 1895. The material further includes
miscellaneous items: a photograph of
Bloemfontein Irish Hospital (Boer War);
a place card for a committee dinner of
the Cambridge Junior Conservative
Club, December 1885; and five
postcards, one of Desart Court by the
commercial photographer Poole of
Waterford.

Áine Ceannt, widow of Éamonn Ceannt, with her sisters Lily O'Brennan and Kathleen O'Brennan, and an unidentified friend, *ca. 1940.*
(Ceannt Collection. Trans. 91)

Áine Ceannt was the wife of Éamonn Ceannt (1881-1916). He was a patriot active in the Gaelic League and the Irish Republican Brotherhood. He was one of the seven signatories of the 1916 Proclamation of the Republic, executed in 1916 at Kilmainham Jail. Áine O'Brennan Ceannt was active in politics, a vice-president of Cumann na mBan, and an officer in the Irish White Cross, a children's relief organization. Mrs. Ceannt's two sisters, Lily O'Brennan and Kathleen O'Brennan,

were also active republicans.

This small personal collection contains a miscellany of images: photographs of crowds at an unidentified celebration in 1932; Enniskerry, March 1938; Tillingfield; a group portrait of students at an Irish-speaking girls' school in Connemara; three images documenting a disturbance in "sisters bedroom"; a small photograph of Éamon de Valera attached to ribbon badge, 1924; and a pencil drawing of an unidentified young man.

■ **Áine Ceannt Photograph Collection**

1925-1938
10 photographic prints, plus several miscellaneous items

ACCESS:
PC97 Lot26.

RELATED COLLECTION:
Kathleen O'Brennan Photograph Collection.

PROVENANCE:
From the papers of Áine Ceannt; various years.

■ **Celbridge Album**

1990
1 album : 160 photographic
prints (colour)

ACCESS:
Album 31.

PROVENANCE:
Gift; 1991.

This album, entitled "A Photographic Record of Celbridge, April/May 1990, by Celbridge Camera Club members", provides modern views of the town of Celbridge, including roads, houses, and aerial photographs of the area. This

material represents the kind of urban documentation projects planned and carried out by organised groups of amateur photographers. The album include a subject index to the photographs.

■ **Edward C. Chandler Photograph Collection**

1855-1940; bulk 1850-1890
ca. 1190 photographic prints
(cartes-de-visite)
ca. 130 photographic prints
(cabinet cards)
ca. 100 photographic prints
(stereographs)
miscellaneous items including
ambrotypes and glass lantern
slides
a selection of publications about
19th-century photographs

ACCESS:
PC97 Lot16(1-40). A checklist of collection contents by Mr. Chandler accompanied the collection and a reference aid has also been compiled.

RELATED PUBLICATIONS
AND EXHIBITIONS:
By Edward C. Chandler: Through the Brass-Lidded Eye: Ireland and the Irish 1839-1859, the earliest images; *exhibited at the Guinness Hopstore, Dublin, Autumn/Winter 1989.* Photography in Dublin during the Victorian Era. *[Dublin]: Albertine Kennedy Publishing, [1982].*

PROVENANCE:
Purchased from Edward Chandler; 1994.

Edward Chandler, of Dublin, is a collector and independent historian of Irish photography, specifically of the Victorian era. He has published several important articles on the subject. This select material is from his own collection. The photographs demonstrate the uses of photography in Ireland from its beginnings in the 1840s up to the mid-1890s. The largest component of this collection consists of cartes-de-visite portraits of unidentified people. These represent the work of numerous Irish studios, arranged in alphabetical order by studio (104 studios in Dublin, 36 studios in Belfast, 17

companies in Cork, and other towns). Other components of the collection include cabinet cards of unidentified sitters; stereographs, including a set, *ca.* 1857, of Clonmel and environs by William Despard Hemphill; lantern slides in their original containers, some Dufaycolor transparencies, an early ambrotype portrait. It also includes a counterfeit carte-de-visite purporting to be of William Smith O'Brien and Thomas Francis Meagher in Kilmainham Jail in 1848. Additional non-photographic items include various publications on photography from the 19th and 20th centuries.

Clonmel, an early stereo view of a house party by William Despard Hemphill, *ca.* 1858. (Chandler Collection. Trans. 92)

Photographs in the Clonbrock collection were taken by members of the family of Dillon, Barons Clonbrock, of Ahascragh, Co. Galway, over a wide span of years. In particular, Luke Gerald Dillon, Fourth Lord Clonbrock, and his wife, Augusta Crofton Dillon (formerly of Moate Park, Co. Roscommon), amateur photographers before their marriage in 1866, were enthusiastic recorders of life on and near the estate. The couple had a studio and darkroom constructed on the grounds. In documentation this is referred to as the "Photo house". Clonbrock House was destroyed by fire in the early 1990s, but the photo house survived. Restoration efforts are being made at Clonbrock House.

Subjects of the photographs include daily life on the estate, the house and household, staff, neighbours, friends and family members. In addition, there are views of other estates and locales, scenes of the changing of the guard in London, and a variety of family related images. This material is a substantial pictorial record of life on a landed estate over a 70-year period of much social and political change in Ireland.

■ **Clonbrock Photograph Collection**

1860-1930
ca. 3,500 glass negatives
ca. 300 glass lantern slides
1 album : 71 photographic prints

ACCESS:
The album is held in the Manuscripts Department (MS 19676). Negatives and lantern slides are accessible to staff only. A card index to 350 of the glass negatives is available.

A tea party following a cricket match in turn-of-the-century Co. Galway. (Clonbrock Collection. Clonbrock 22)

Sir Joscelyn Coghill, Bt. (1826-1905) was an early photography enthusiast in Co. Cork, winning a prize in the Paris Exhibition, 1863, for a photograph of Roger's Island. Using the wet plate negative process of the era, he took numerous photographs of the family and environs of the family estate of Drishane, Castletownshend, Co. Cork. Coghill was the brother of the mother of novelist Edith Somerville, who lived at Drishane.

This collection comprises modern copy prints from original prints of a selection of Coghill's wet-plate negatives. The photographs depict members of the Somerville and Coghill families and the estate of Drishane and environs, 1860-65. Views include landscapes around Castletownshend, the quay, village and harbour; members of the family including Dr. James Somerville, his wife Ellen ("Aunt Ellen"), daughters Grace,

Nellie, "Ada" (Edith), and dog; Egerton Coghill painting; the sailboat *Ierne*; family group of Henry Somerville, Edith Somerville, Violet Martin, et al.; four boys bathing on Cosheen Strand; the West Carbery Hunt; Edith Somerville and Violet Martin drinking tea at the fireside; other similar images of family and recreational activities. The copy prints are captioned in pencil on versos by the donor.

The subjects of some of these images, Edith Somerville (1858-1949), and her second cousin Violet Martin (1862-1915), as Somerville and Ross, wrote a popular series of novels portraying the last days of the Anglo-Irish ascendancy in the late Victorian era. Somerville also painted and illustrated, exhibiting until she was seventy-five. She was Master of the West Carbery Foxhounds for a period, and spent most of her life at Drishane House.

■ **Sir Joscelyn Coghill Photograph Collection**

1865-1900
49 photographic prints (copy prints)

ACCESS:
PC97 Lot22.

RESTRICTIONS:
This is primarily a study collection; donor permission is expressly required for reproduction for any purpose.

PROVENANCE:
Purchased from Sir Toby Coghill, Bt., great-grandson of the photographer; 1985.

A typical portrait studio at the end of the last century. (Wynne Collection (see page 106). Wynne 1685)

■ **Congested Districts Board Photograph Collection**

**1906–1914
120 photographic prints, including 2 photographic postcards**

ACCESS:
PC97 Lot14. Surrogate copies are available for reference.

RELATED PUBLICATION:
Ireland's Eye: The Photographs of Robert John Welch. *Selection and commentary by E. Estyn Evans and Brian S. Turner. Belfast: Blackstaff Press, 1977.*

PROVENANCE:
Gift of the Irish Land Commission; 1976-1986.

The Congested Districts Board, established in 1891, was a government body that attempted to promote development, by redistribution of land, rebuilding and improvement of harbours and roads in the poorer counties along the Ireland's west coast, including Mayo, Galway, and Donegal. The work of this board continued until 1923 when the Land Commission took over its functions.

These photographs are principally 105 images made by Belfast photographer Robert J. Welch, documenting congested (i.e., poor and over-populated) districts along the western coast, and resettlement of tenants from those districts in new or improved houses. Images depict subjects

such as: rundale plots (traditional farming tracts) near Castlebar, Co. Mayo; a new concrete block house built for John Commons, a small farmer who migrated from one of the congested districts to Rychill, Monivea, Co. Galway, 1914. Other images are by J.D. Cassidy, a photographer in Ardara, Co. Donegal. The material includes a series of images of women salting fish and a wharf with fishing boats, possibly Killybegs, Co. Donegal; Lady Aberdeen outside a new dwelling; a visiting nurse at the home of a poor family; a new concrete house in the framing stage; inhabitants, including children, in various locales; new houses on Mellenish Island; an informal group portrait of members of the Horace

Plunkett Inquiry at Old Head, 1906. Among the photographs by Welch are several pairs of prints forming panoramic views—wide-angle scenes of 180 degrees, such as that seen below.

Robert J. Welch (1859-1936) was a prominent Belfast photographer in the late 19th and early 20th centuries. He photographed widely in the north of Ireland, especially Belfast, and was official photographer for firms including the Harland and Wolff shipbuilding company. He was commissioned by the Congested Districts Board for work in June 1914. Those images by him are annotated in what appears to be his handwriting; these include negative numbers.

Composed of two regular photographs, this wide-angle or panoramic view of a rural setting was taken for the Congested Districts Board, 1914, by Belfast photographer Robert Welch. Note that the same group of children features twice in this image. (Congested Districts Board Collection. R 28,190 and R28,189)

■ **Coolgreany Evictions Album**

1887
1 album : 46 photographic prints
(albumen)

ACCESS:
Album 83.

PROVENANCE:
*Gift of Mrs. Bridie Hogan,
Taringa, Queensland, Australia,
August 1992. Mrs. Hogan's mother
was a niece of Fr. Farrelly to whom
the album was given.*

Entitled "Coolgreany Evictions" on its cover, this is an album of photographs taken at the evictions on the Brooke estate at Coolgreany, near Gorey, Co. Wexford, in 1887. These images by an unknown photographer include portraits of evicted families, specifically the Kavanaghs of Croghan; also, images of Fr. Laurence Farrelly, and the Johnstown chapel. Fr. Farrelly was a local parish priest during the evictions, an active

participant in Wexford's Plan of Campaign, who helped move those evicted to shelter. The Coolgreany evictions were covered by local newspapers. At least one image is included in the Lawrence Collection.

The album includes a letter from a Fr. T. Mallacy, who assembled the album, and gave it to Fr. Farrelly in 1888. The album (14" x 10") is in poor condition; the photographs are in fair condition.

Three unidentified men probably members of the evicted families in 1887. (Coolgreany Album 83. Trans. 94)

This large and varied collection represents the National Library's best known and previously published images. These 4" x 5" black-and-white and colour copy negatives and colour copy transparencies were made from the Library's general holdings, principally photographs but also textual materials including printed books, manuscripts, maps, deeds, and newspapers. They were generated as a by-product of creating copy prints for patrons' research, publication, broadcasting, and exhibition purposes. The negatives and transparencies created since 1979 are by the Library's staff photographer Eugene Hogan. Prior to that the collection was developed by a number of the Library's staff; John Rowe, Dick Mooney, Philip McCann and Tom Desmond.

This collection of materials was begun in 1948; as of 1996, it increases annually by approximately 1,000. While not comprising original materials, the collection is valuable as it contains the select group of images chosen by staff, scholars, and researchers as having particular merit, either visual or documentary. The materials also serve a preservation function, some being second copies of glass negatives. The Library requests that publications using its images include the copy negative number in the publication for ease of subsequent printing.

Separate copy negative and transparency series, numbered according to the collection's original system, also exist for portions of the following collections: Cardall, Clonbrock, Eason, Eblana, Keogh, Lawrence, Morgan, O'Dea, Poole, Stereo, Tempest, Tenison, Valentine, Wynne.

■ **Copy Negative Collection**

1948-present (ongoing)
approximately 29,000
photographic negatives
180 photographic transparencies

ACCESS:
Accessible to staff only. Each negative is indexed under at least one subject term in card catalogues of Persons, Places, and Subjects. Other card catalogues providing access to this collection are: Date of event depicted, Newspaper, Deed/Manuscript, Exhibition/Publication, Periodicals/Books, and Maps.

PROVENANCE:
Created by the National Library beginning in 1948.

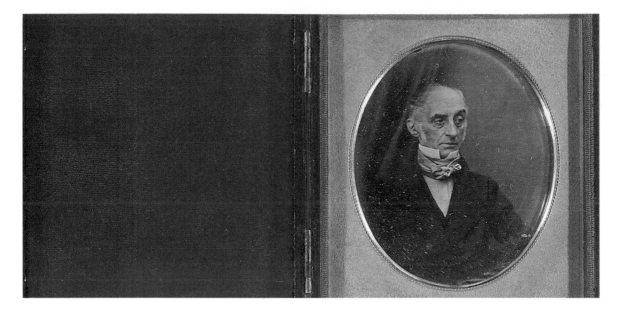

■ **Daguerreotype Collection**

1839-1860
5 daguerreotypes

ACCESS:
By personal application.

PROVENANCE:
Various sources.

Daguerreotypes were introduced by Louis-Jacques-Mandé Daguerre in France in 1839. No negative is created so exact duplicates could not be made; however, the image was very clear and detailed. The image—usually a portrait—is on a thin sheet of copper coated with silver and exposed. The image on the plate was then covered with glass and framed in an ornate plastic case lined with fabric and/or leather. Although not inexpensive, daguerreotypes were popular through the mid-1850s. Few of them were made in Ireland. At least one in the collections is from an American maker.

There is not a collection as such of daguerreotypes in the Library. The materials are in several personal photograph collections.

Above: An attractive example of daguerreotype unidentified portraiture, wherein the fine detail can be noted. (Daguerreotypes. Trans. 95)
Below: A rare stereo daguerreotype, *ca.* 1850, of Lady Whitehead. (Daguerreotypes. Trans. 96)

This album contains photographs of buildings designed by Thomas Manly Deane (1851-1933), ARHA architect, and son of prominent architect Sir Thomas Newenham Deane (1828-1899). Together they designed the National Library and National Museum. Images in the album depict architectural details, including baptismal fonts, plasterwork, high crosses, furniture; residences, McArthur's Hall in Belfast, and the Royal Exchange Building in Dame Street in Dublin. Also included are photographs of architectural drawings, including plans and elevations of the National Library.

■ **Thomas Manly Deane Album**

1886-1902
1 album : *ca.* 100 photographic prints (albumen)

ACCESS:
Album 74.

In turn-of-the-century Dublin, architect Thomas Manly Deane designed the Electric Company Building on the corner of Dame Street, beside the photography shop. (Deane Album. Trans. 97)

■ Dillon Album

1880-1920
1 album : 19 photographic prints

ACCESS:
Album 101.

PROVENANCE:
Purchased from Ms. Sheila Walsh; 1994.

The creator of this album, a Ms. Dillon, worked in the racehorse training business in Ireland in the early 20th century. This album is one of several items in the photographic archive that documents horses, horse breeding and horseracing in Ireland in the late 19th and 20th centuries. The album is bound in green and black leather, with a metal horseshoe surrounding the name "C.D. Rose Hardwick". It contains portraits of horses, dated 1889-*ca.* 1900, captioned with their pedigrees. Some captions include selected track records (form), e.g., Epsom, Ascot, Newmarket. Some horses depicted are: Gulliver, Myrrh, Lorette, and Siberia. Also included is a drawing, on the verso of a letter, of the racehorse Bonavista winning a 2000-guinea race.

The winner of a number of races in Ascot, "Gulliver" was sold for £4,000 in 1891. (Dillon Album. Trans. 98)

The Royal Dublin Society, Ballsbridge in the 1920s. (Eason Collection (Eason 1652). See also page 27.)

■ **Dripsey Woolen Mills Album**

1925-1926
1 album : 113 photographic prints

ACCESS:
Album 78.

The Dripsey Woolen Mills, Co. Cork, was owned by the O'Shaughnessy family. This album depicts family members and friends at leisure, some exteriors of the woolen mills, and workers on the grounds of the factory. Few images are captioned. The images offer a rare look at a family textile industry and factory workers in 1920s Ireland.

■ **Leland Lewis Duncan Photograph Collection**

1889
43 photographic prints (copy prints)

ACCESS:
PC97 Lot21. A typewritten checklist is enclosed with the materials.

RELATED PUBLICATION:
The Face of Time: Leland Lewis Duncan, 1862-1923: Photographs of Co. Leitrim, *compiled and introduced by Liam Kelly. Dublin: Lilliput Press, 1995.*

PROVENANCE:
Acquired from Fr. Liam Kelly; 1994.

RESTRICTIONS:
Donor permission is required for reproduction of images.

Leland Lewis Duncan (1862-1923), English historian, antiquarian, folklorist and photographer, had cousins, the Slackes—landed gentry—who lived at Annadale in Co. Leitrim. Duncan visited them in the summers of the late 1880s and early 1890s. He also collected folklore in the area and published a pamphlet on the subject in the 1890s.

This material is collectively entitled as though it were an album: "A Holiday in Ireland—views at and near Annadale, Carrick-on-Shannon, Co. Leitrim, August 1889, by Leland L. Duncan." These modern copy prints show views, houses and cabins, church ruins, people including servants and tradesmen, horses and dogs. This collection is of interest, as the Library's photographic holdings otherwise include slight coverage of Leitrim for the period.

In turn-of-the-century Dublin, Eason & Son was a firm specialising in wholesale and retail books, newspapers, and stationery, including photographic postcards. When the company's shop in Sackville Street (now O'Connell Street) was destroyed by fire in 1916, the negatives were stored elsewhere—like a portion of the William Lawrence negatives—and so survived. Eason's printing operation closed in 1941; the firm still operates a thriving chain of book and stationery stores.

The images in this collection were created for the Irish views postcard trade by Eason & Son. Images depict all parts of the island; the firm had sales kiosks at railway stations. Cards were published under the imprint Signal. The firm created specialised cards for customers including business firms and religious institutions.

The negatives, of various sizes, were generated by several different photographers, and sometimes by clients. Some are inscribed with 'Poulton' signifying that Eason's acquired some of the (Irish views) negatives of Poulton & Son in London.

■ **Eason Photograph Collection**

1900-1939
4,092 glass negatives

ACCESS:
Accessible to staff only. A reference aid is available: a bound volume entitled "Eason Photographic Collection—Index" contains the list of negatives, in number order, with a brief description of each. Also includes a place name index.

PROVENANCE:
Acquired after 1941.

Harcourt Road, Dublin taken in the 1940s; the area has since changed completely. (Eason Collection. Eason 1,783)

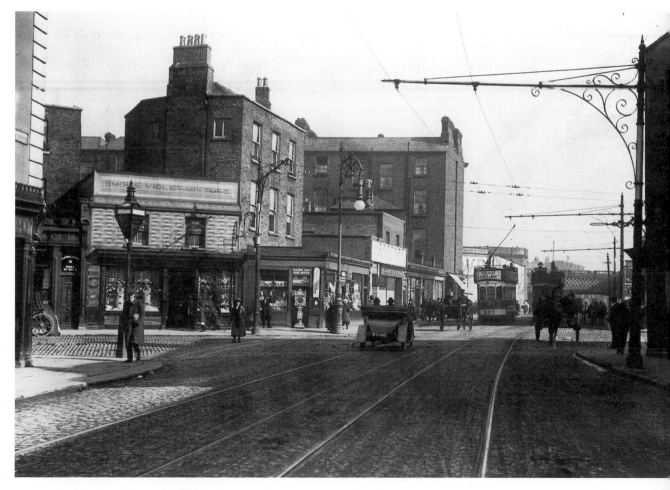

■ **Easter Rising and Civil War Pamphlets**

1916-1922
8 items : 5 published pamphlets and 3 personal albums

ACCESS:
A bound photocopy of all eight pamphlets is available as a reference aid. The original albums are available by personal application. See description for individual album numbers.

PROVENANCE:
Various sources.

This group of published pamphlets and personal albums depicts Dublin before, during and after the Rising of April 1916, and the Civil War, 1922. Among images in the materials are portraits of persons prominent in various aspects of the Rising. Specific pamphlets and albums are as follows:

Dublin After the Six Days Insurrection. Thirty-One Pictures from the Camera of Mr. T.W. Murphy ("The O'Tatur"), sub-editor of The Motor News. Picture Souvenir—The Sinn Fein Rebellion. Dublin: Mecredy, Percy & Co., Ltd., [1916]. Album 252

Pictures of Dublin—After the Fighting, June-July, 1922. [Dublin: 1922].

Comprises thirteen photographs taken by W.D. Hogan, Dublin, with short captions. Album 253

The Sinn Fein Revolt Illustrated. Printed and published by Hely's Limited, Dame Street & Acme Works, Dublin, 1916. Comprises 45 images of leaders of the Rising, important documents, and scenes of Dublin, as illustration for extensive text. Photos are credited to T.W. Murphy, Keogh Bros., Lafayette, and others; text by "J.W.M." Album 251

Old Ireland in Pictures. Issued by Wilson Hartnell & Co., Dublin, 1916(?). Comprises *ca.* 38 pages of text heavily illustrated with reproductions of portraits of 18th- and 19th-century Irish

Dramatic postcard view of Dublin's quays following the Rebellion; touched up for dramatic effect. (Valentine Collection. R. 27,449)

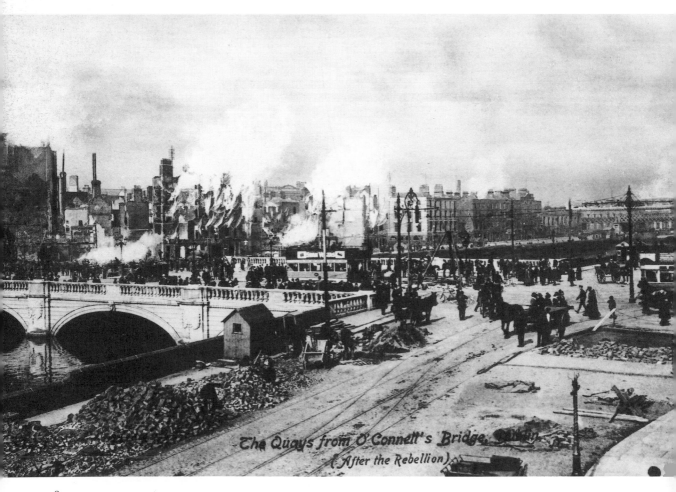

The Quays from O'Connell's Bridge, Dublin.
(After the Rebellion)

political leaders; the Battle of the Boyne; Dublin views; the House of Lords (Ireland) in session, *ca.* 1713. Also includes documents and photographs of Dublin before and after the 1916 Rising. Album 250

The Rebellion in Dublin, April 1916. Published pamphlet, 1916(?). Twelve postcard-size photographic prints of people and places important in the 1916 Rising. All cards are captioned; some are credited to Chancellor. Album 254

"Pictures of Dublin After the 1916 Insurrection". A personal album of twelve postcard-size photographs, captioned by the unnamed collector but not credited.

"Miscellaneous Postcards, Easter 1916". A personal collection of thirty-seven published postcards, some credited to W.D. Hogan. Most are photographs; a few relate to Ulster and Home Rule.

"Post Cards illustrating Irish Rising, 1916. Gift of Art Ó Murnaghan (1927)". A personal album of 90 photographic and photolithographic postcards; includes 44 portrait postcards of those prominent in the Rising (the series headed "Irish Rebellion, May 1916"), and views of Dublin relating to the Rising and subsequent events, including some from Valentine & Sons' "Sinn Fein Rebellion" series. Album 113

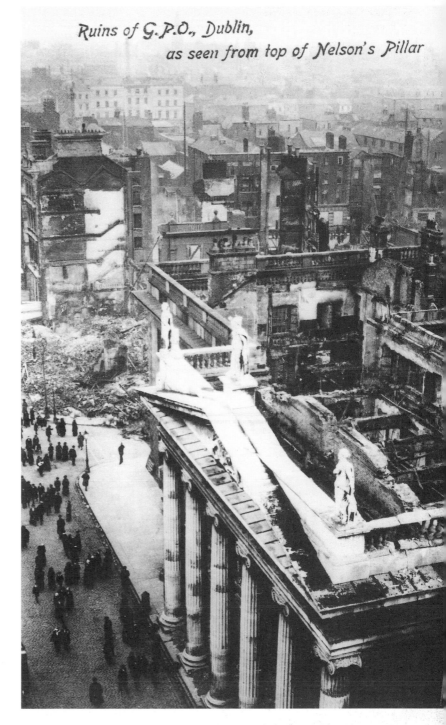

A view over Dublin from Nelson's Pillar in the days following the Rising. (Valentine Collection. R27,448)

■ **Eblana Photograph Collection**

1870-1890
ca. **2,900 glass negatives**

ACCESS:
Accessible to staff only. A card index has been copied onto a list format and provides access by town and county, giving the negative number.

PROVENANCE:
Purchased; 1943.

The Eblana series is a distinct part of the Lawrence Photograph Collection. The materials were probably purchased by William Lawrence or his brother for printing and distribution rather than created by the Lawrence company photographers. This series includes topographical views of various cities, towns, and rural areas in Ireland, plus fewer than 100 non-photographic glass negatives for postcards of religious and comic subjects. A selection of 1880s eviction images is part of the collection. Most of the negatives include two identical images per plate, probably for speed in printing. They are not stereo pairs.

The Rotunda at the top of Sackville Street, the posters along the railings advertise Pepper's Ghost which first played in Dublin in late 1860s. (Eblana Collection. Eblana 3)

The Edgeworth collection contains family photographs and photographs relating to the career of Lieut.-Col. Kenneth Essex Edgeworth (b. 1880), DSO MC, of Kilshrewly, near Ballinalee, Co. Longford. In 1898, Edgeworth obtained his commission in the Royal Engineers and served in South Africa, Somaliland, and Egypt prior to the First World War. During that war he worked with a signal company responsible for maintaining communications in France. He married a widow, May (Piggott) Eves, in 1917, and later he was Chief Engineer for the Department of Posts and Telegraphs in the Sudan. After retirement to Dublin in 1931, Edgeworth published four books on Irish trade and unemployment. As a boy, Edgeworth had taken up the hobby of photography, making glass plate negatives and platinum prints. He continued to take photographs throughout his life.

The collection documents Edgeworth's career and family life over a long period. Of note are Edgeworth's photographs in South Africa during the Boer War, images taken during a trip on the Sudan Railway, the Nile, and those of the 1901 construction of a bridge over the Assegal River, near Piet Retief in the Eastern Transvaal. The collection also includes cabinet cards of Edgeworth at various ages; cartes-de-visite of his wife's ancestors John Trench Piggott and Isabel Mary Piggott; "grandmother Lucy Piggott," *ca.* 1875; a studio portrait of Maj. John McBride, Irish Brigade, Boer War 1900; an unidentified man in uniform, from a Cairo photographer, *ca.* 1900; a group of military officers.

The various albums of mostly uncaptioned photographs show scenes probably taken by Edgeworth while touring Ireland in the 1930s as well as Irish houses and castles, some European views (Nice, 1919 and 1939), unidentified cartes-de-visite (one from a Ceylon studio) and cabinet card portraits in a large carte-de-visite album. At least four albums include images in South Africa, *ca.* 1901 and *ca.* 1929; building of the Assegal River Bridge, soldiers having a rope tug-of-war, pontoon troops crossing a river, boring for water at Standerton; and some informal portraits of soldiers and native staff.

■ **Kenneth Edgeworth Photograph Collection**

1870-1965
ca. 150 photographic prints, and some corresponding film negatives
17 glass lantern slides
13 albums : *ca.* 650 photographic prints

ACCESS:
Albums 200-213. Loose prints are held at PC97 Lot19.

PROVENANCE:
From the papers of Kenneth Edgeworth in the Manuscripts Department; 1973.

Boiling up the billy can in South Africa. (Edgeworth Collection, Trans. 99)

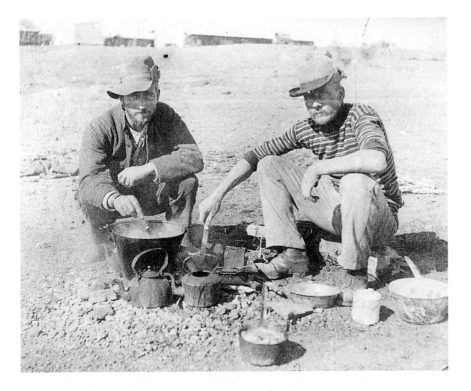

■ **William G. Fay Photograph Collection**

1915-1950; bulk, 1920-1935
40 photographic prints, plus
miscellaneous items

ACCESS:
PC97 Lot27.

RELATED PUBLICATION:
Fay, W. G. and Catherine Carswell.
The Fays of the Abbey Theatre:
An Autobiographical Record.
London: Rich & Cowan, Ltd., 1935.

PROVENANCE:
From the papers of William G. Fay;
gift of Gerard Fay; 1960; acc. 2174.

RESTRICTIONS:
Reproduction of film production
stills may be restricted.

This material consists mainly of photographs of scenes and actors in plays and films in which Irish actor-manager William G. Fay (1873-1947) appeared or which he produced, especially in the 1920s and 1930s. Fay was stage manager of the Irish National Theatre Society, and then helped establish the Abbey Theatre in 1904. He left Ireland in 1908 and with his actor brother Frank went to the United States, and then England, to continue his acting career.

Photographs include studio portraits of Fay and of other actors, including Arthur Shields; also, family portraits, including the Gallagher family, *ca.* 1916.

There are also photographs from plays of the 1910s and 1920s: "The Silver Box," Repertory Theatre, Birmingham; "Aren't Women Wonderful?" (with a heavily made-up young Laurence Olivier, author Dorothy Turner, Fay, and others); "Fr. Malachy's Miracle"; "In the Shadow of the Glen"; and "The Call". It further includes film production stills from feature films of the 1930s and 1940s: "Oliver Twist", "Odd Man Out", "Spring Meeting", "London Town", "General John Regan", and "Spellbound". Also includes promotional card for "The Romantic Age," Abbey Theatre, 1926; and a drawing by H. Heuzy for "The Gondoliers."

William G. Fay (on the right) had roles in Hollywood films, including "Spring Meeting" (1947). (Fay Collection. Trans. 100)

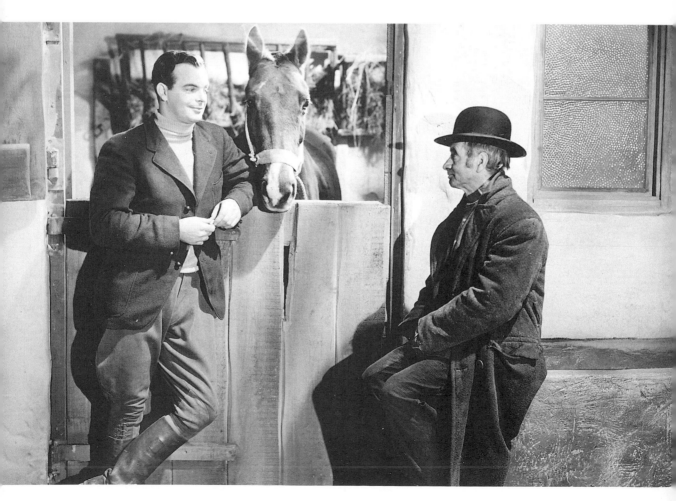

The Fenian Album is a typical small carte-de-visite album, with ornate cover and metal closures, containing identified and dated portraits of various men, some of whom were known to be active in the Irish republican oranization known as the Fenians, founded in 1858 in New York. The album also includes at least one image of a member of a parallel organisation, the Irish Republican Brotherhood (IRB), founded simultaneously and on the same principles in Ireland. Fenians fought on both sides of the American Civil War (1861-1865); the Fenian regiment of the New York National Guard was led by Col. John O'Mahony. The Fenians metamorphosed into a more enduring form which helped bring about Irish independence in the 20th century.

Other prominent Fenians were James Stephens, Col. Thomas J. Kelly, Gen. John O'Neill, Capt. John McCafferty, and Ricard O'Sullivan Burke.

Among those portrayed in this album are: John O'Mahony, James Stephens, Jeremiah O'Donovan Rossa, Isaac Butt, Michael Moore, Geo. Archdeacon, Charles J. Kickham, Thomas Clarke Luby, Captain Michael O'Boyle. A few sitters are in American Civil War uniforms. Some of the cartes are from the studio of C. Fitzpatrick, Thomas Street, Dublin. A number of the cartes were removed before the Library acquired the album. Some images have handwritten identifications of the sitters and other annotations, such as information about their military service in the United States.

■ **Fenian Album**

1865-1870
1 album : 26 photographic prints
(cartes-de-visite)

ACCESS:
Album 37.

PROVENANCE:
Transferred from the Manuscripts Department.

The Fitzelle album contains images taken during the Civil War of 1922, specifically Dublin and Limerick between May and July 1922. Most of the photographs were taken by Dublin photographer W.D. Hogan with official sanction; some are stamped "passed by censor". The majority depict Free State forces on active service. Subjects include: two young boys playing soldier outside the gates of the Four Courts, sandbags in position, April 1922; the funeral of Michael Collins, 28 August 1922; hotel ruins and destroyed tram lines; guns firing from G.P.O./Henry Street corner.

■ **Fitzelle Album**

1922 or 1923
1 album : 33 photographic prints

ACCESS:
Album 135. Photocopies are available as a reference aid.

RELATED COLLECTION:
W. D. Hogan Photograph Collection.

PROVENANCE:
Acquired from Mr. A.E. Fitzelle and from Rev. Colm Mathews.

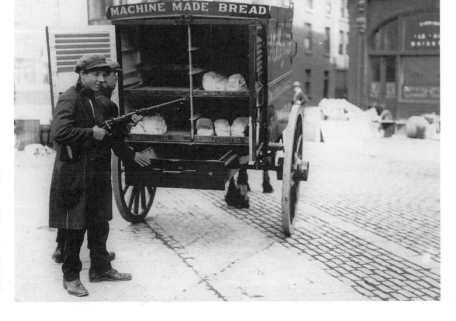

Boys with guns search open back of bread truck, 1922. (Fitzelle Album. R. 22,405)

■ **William Henry Fox Talbot's** *The Pencil of Nature,* **Part 2**

1844-1845
1 volume : 12 photographic prints

ACCESS:
Album 188.

PROVENANCE:
Acquired by the Royal Dublin Society Library, probably 1845.

In 1839, William Henry Fox Talbot (1800-1877) of Lacock Abbey, Wiltshire, made public his discovery of what he called "photogenic drawing", the precursor of his use of paper negatives (1840). In France, also in 1839, Louis Daguerre had made known his own discovery of the single-impression daguerreotype, but Fox Talbot's negative-positive technique endured. Fox Talbot published *The Pencil of Nature* (London, 1844-1845) in a series of six parts; this described and illustrated the photographic process. The Library's holdings contain number two of this rare set.

Gate of Christchurch College in Oxford University. This is one of the 12 plates, illustrating the second volume of Henry Fox Talbot's pioneering work *The Pencil of Nature*. (*The Pencil of Nature.* Trans. 186)

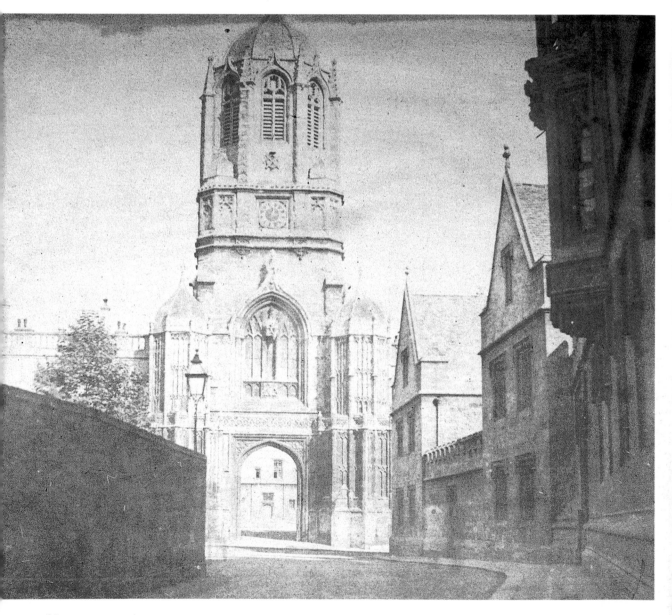

Alice Stopford Green (1847-1929) was an historian and nationalist. Born in Co. Meath, Alice Stopford moved to London *ca.* 1874, married historian John Richard Green three years later, collaborated with him, and specialised in medieval history. In 1908 she published *The Making of Ireland and Its Undoing* about the period 1200-1600. Her home rule sympathies led to her friendship with Roger Casement. She disapproved of the 1916 Rising, but returned to Dublin and lived at 90 St. Stephen's Green thereafter. She supported the 1922 Treaty, helped organise Cumann na nGael, the pro-Treaty political party, and was elected as one of four women members of the first Irish Senate. She wrote the last of her numerous books, *History of the Irish State to 1014*, in 1925.

These few personal photographs are from Green's papers. They include three studio portraits of Green at various stages of her life, snapshots of her, *ca.* 1898; and as senator with Gen. Richard Mulcahy, *ca.* 1920. There are also miscellaneous photographs.

■ **Alice Stopford Green Photograph Collection**

1884-1945
18 photographic prints

ACCESS:
PC97 Lot45.

PROVENANCE:
From the papers of Alice Stopford Green; gift of Mr. Robert Stopford; 1966.

Cabinet card portrait of Alice Stopford Green, *ca.* 1875. (Green Collection. Trans.101)

Peregrin and Rosalyne, young members of the extended Haffield family. (Haffield Albums. Trans. 102)

■ **Haffield Albums**

1860-1930; bulk, 1900-1920
26 albums : *ca.* 850 photographic prints

ACCESS:
Albums 41, 42, 47, 48-50, 54, 55, 66-70, 126, 129, plus others.

PROVENANCE:
Purchased; ca. 1984.

This extensive collection comprises personal albums of amateur photographs taken by members of the Haffield family of Kingstown, Co. Dublin, and the Archer family (especially Claude Archer) of Co. Louth and Co. Meath. The relationship between these families has not been fully researched.

This rich array of materials primarily documents scenes and events in Kingstown (Dun Laoghaire) and other south Dublin locales, including boats,

the Bray train, and seaside recreational activities. It also includes Dublin events such as the 1900 visit of Queen Victoria, the 1903 floods, the 1907 visit of King Edward VII, parades, an auto race in Phoenix Park, and the Royal Dublin Society. A few family photographs are included. Images of estates in Ireland can also be found here. Most images are from 1900 to 1920. Images in the albums are not always arranged in chronological order; also, similar images can be found in several albums.

■ **James Augustine Healy Photograph Collection**

1948-1954
7 photographic prints

ACCESS:
By personal application.

PROVENANCE:
From the papers of James Augustine Healy; 1951.

These photographs are from the personal papers of James Augustine Healy, professor of Irish literature at Colby College, Waterville, Maine. Healy's two major gifts to the college are documented here. They were a run of Cuala Press publications in 1948, and a set of first editions of the works of James Brendan Connolly (1868-1957), Irish-American

writer of sea stories. Images include 10" x 8" black-and-white portrait photographs of Connolly, dated 1948, 1951 and 1954. Other images show Connolly receiving honorary degrees at Fordham University (1948) and at Colby College (1950). Another image shows a display of Cuala Press books and prints at Colby College, summer 1953.

The National Library is the background, and Milo O'Shea appears as Leopold Bloom in film production still for "Ulysses", 1967. (Hickey Collection. Trans. 103)

Des Hickey, born in 1931, was a columnist for Dublin's *Sunday Independent*, specialising in the arts; he also was a broadcaster, author, and documentary film scriptwriter. His younger brother was Kieran Hickey, filmmaker and author of a book about the Lawrence Collection, *The Light of Other Days*, 1973.

The photographs in this collection fall into three subject areas: the Wexford Festival, 1960s and 1970s; authors, journalists, and literary people; and stage and film actors and performers. The Wexford Festival, which began in 1951, is represented by 47 images of performances, backstage scenes, performers socialising, and publicity photographs. Operas depicted are: "Il Pirata," 1972; "La Pietra del Paragone," 1975; "Fra Diavolo," 1966; "Lucia di Lammermoor," 1964; "Romeo et Juliette," 1967; "Otello," 1967; "Lucrezia Borgia," 1966. Performers include Ugo Benelli, Sandra Browne, Nigel Douglas, Alberta Valentini, Reni Penkova, and Paul O'Dwyer. Photographers were Andrew Sproxton, York, and Denis O'Connor, Wexford.

The second general grouping— literary notables—contains 12 images from the launch of Des Hickey and Gus Smith's book; *A Paler Shade of Green* on Dublin's performing arts and literary personalities (London: Leslie Frewin, 1972), showing guests Jack McGowran, Mícheál MacLiammóir, Hugh Leonard, Anna Manahan, among others, and the authors; all were taken by Charles Collins, Dublin. Many of the images in the book are included in this group.

The third category is performers. This material falls into several folders, one containing 99 photographs of actors, singers, authors, and others, such as Christy Brown, Alun Owen, Cyril Cusack and John Ford; Daithí O Háinle; Hilton Edwards as Herod, 1969; Tyrone Guthrie and Mícheál MacLiammóir; Richard Harris and Milo O'Shea in the 1967 film "Ulysses"; Tom Murphy, Pádraic Colum, Brian Friel, Tomás MacAnna, Norman Rodway; Donal Donnelly. Many photographs were taken by Charles Collins, Dublin. In another folder are: Michael Caine, Laurence Harvey, Julie Christie, Simone Signoret, and others. The Hickey Collection also includes miscellaneous groups of images of John F. Kennedy in Ireland, 1963; Eamon Andrews boxing, 1950s; Richard Harris; Finbar Wright; and Brendan Behan with Cecil French and eight unidentified women.

■ **Des Hickey Photograph Collection**

1953-1990
ca. **200 photographic prints**

ACCESS:
PC97 Lot28.

RESTRICTIONS:
Commercial photographs may have copyright restrictions.

PROVENANCE:
Acquired from Mr. Roy Hill; October 1992.

■ Patrick Hillery Photograph Collection

1965-1989
ca. 113 albums of photographic prints : *ca.* 3000 photographic prints
numerous loose photographic prints, framed portraits, and postcards

ACCESS:
By personal application.

PROVENANCE:
Gift of Mrs. Maeve Hillery; January 1996.

Patrick John Hillery (b. 1923), politician, and President of Ireland (1976-1990), was born in Co. Clare. In 1951 he was elected to the Dáil, married Dr. Mary Beatrice "Maeve" Finnegan in 1955, and was Minister in several Fianna Fáil governments, from 1959 to 1972. He then left politics to be a Vice-President of the Commission of the European Economic Community (EEC) in which he was responsible for Social Affairs (1973-1976). He was inaugurated President of Ireland in November 1976, serving through to 1990.

The albums and photographs comprising this extensive collection mainly document Hillery's activities in the EEC and as President of Ireland. Also included are family photographs, including formal portraits, and family and holiday snapshots.

Many of the albums are formal records of trips abroad by Hillery as Vice-President of the EEC or President of Ireland. For example, the album entitled "Visit of His Excellency Dr. Patrick Hillery, President of Ireland, and Mrs. Maeve Hillery to India, Jan. 24-Feb. 7, 1978" comprises 71 photographs depicting the Hillerys' arrival at the airport, opening banquet, parade, visit to a school, temples, and departure. There are a few personal albums, such as one, *ca.* 1988, including images of the family at Christmas, a family party at Altadore in Blackrock, and other recreational and holiday activities. The collection also includes at least nine framed portraits of leaders of European countries.

The Hillerys having an audience with Pope John Paul II, in 1987. (Hillery Collection. Album 81. Trans. 104)

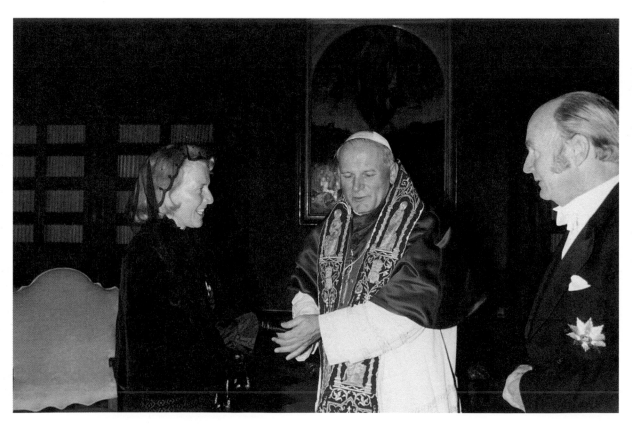

Englishman John Hinde (1916-1997) became interested in amateur photography as a child. By the 1940s he was one of a few enthusiasts in colour photography in Ireland. By the mid-1950s, his work in colour book publishing and with circus publicity had developed his expertise in visually stimulating the public. In 1956, he founded John Hinde Limited, printer and publisher of colour postcards. These cards, by combining a simple landscape view, plus selective retouching, and distinctive colour changes and intensification, depicted a sunny, happy, rural Ireland. In 1963, the firm moved to a new factory in Cabinteely, Co. Dublin. The postcards were by then marketed heavily to tourists in the U.K. as well as Ireland.

In 1972, when the company's sales were over 50 million cards per annum worldwide, John Hinde sold his interest in the company.

Each card in this selection provides a hyper-colourful view of a charming locale in Ireland, including Northern Ireland. Typically, on the back of each card is included an informative caption, plus a small map of Ireland pointing out the location of the image. The "John Hinde Giant Post Cards" also include technical information about the image. Photographers, credited on each card, include John Hinde (until 1967), David Noble, Joan Willis, R. Beer, and Elmar Ludwig. While not themselves photographic prints, these photograph-based cards are a staple of any collection of modern images of Ireland.

■ **John Hinde Postcard Collection**

1957-1972
497 colour prints (postcards)

ACCESS:
By personal application.

RELATED PUBLICATION
AND EXHIBIT:
Hindesight: John Hinde Photographs and Postcards by John Hinde Ltd., 1935-1971. *Dublin: Irish Museum of Modern Art, 1993. Produced for an exhibit of Hinde cards by the Irish Museum of Modern Art in 1993. This work provides a colourful sampler of postcards accompanied by a history of the company and an analysis of the colour process.*

Vivid colour was a hallmark of John Hinde's postcards. These images show costumed performers at Bunratty Castle and red sails on a small boat in Baltimore. (John Hinde Postcard Collection. Trans. 174 and Trans. 175)

g Village of Baltimore, West Cork, Ireland. Photo: D. Noble.

Traditional Irish Singers with Harpist, Bunratty Castle, Co. Clare, Ireland. Photo: D. Noble, John Hinde

■ W. D. Hogan Photograph Collection

1922
58 photographic prints

ACCESS:
PC97 Lots.

RELATED COLLECTIONS:
Easter Rising and Civil War Pamphlets; Fitzelle Albums.

PROVENANCE:
Purchased at auction; 1995.

W.D. Hogan was a commercial and press photographer located in Henry Street in Dublin between 1920 and 1935. It is likely that Hogan took these photographs under contract. The 5" x 7" black-and-white photographs show life in June and July 1922 in Dublin during the early Civil War period, with armed and uniformed men on the streets.

The subject of these images was sparked by disagreement over the Treaty of December 1921 which stated the terms of Ireland's long-sought independence from Great Britain. After the Treaty was accepted in Dáil Éireann in January 1922, anti-Treaty armed forces seized Dublin's Four Courts in mid-April 1922. With that incident, the Civil War proper began. The better-equipped government forces (the National Army) forced the Republicans to use guerrilla tactics. The fighting continued through to May 1923.

These images show mostly the National Army, as opposed to the "Irregulars" (Republicans). They also depict children and other civilians. Other subjects include: armoured cars, men in transport vehicles, men and boys in crowds, burning buildings on the Liffey

quays, Arthur Griffith, an ambulance on O'Connell Street, back of a bread truck with loaves of bread and rifles, and similar scenes. The images are clear and detailed, showing a balance of documentary and human interest. Many prints are numbered, but none are captioned. On the verso of several of the prints is stamped: "W.D. Hogan, photographer, 18 July 1922, 56 Henry Street, Dublin".

Twelve of these photographs were published by Eason & Son in a pamphlet, *Pictures of Dublin—After the Fighting, June-July, 1922.*

Above:
Photographer W.D. Hogan's advertisement in *The Camera*, May 1923. (R. 28,182)

Right:
A prayer vigil, during the Irish Civil War. (Hogan Collection. Trans. 105)

A hand-made title slide describes the Horgan slide set: "The Making of Moby Dick, Youghal, 1954". Thomas Horgan, who died in 1948, was a commercial portrait photographer and amateur filmmaker in Youghal, Co. Cork. In 1917, the Horgan portrait studio was converted to Horgan's Picture Palace, managed by Thomas and his brothers James and Philip.

Thomas Horgan made these photographic lantern slides in 1954 while the Hollywood film "Moby Dick" was in production near Youghal. The slides show the cast (including American actor Gregory Peck as Captain Ahab) and costumed extras, plus production crew, director John Huston, and the film set, including various ships and the Spouter Inn. The slides are not captioned.

■ **Jim Horgan Photograph Collection**

1954
49 glass lantern slides

ACCESS:
Slides are accessible to staff only.

RELATED COLLECTIONS:
The Irish Film Archive includes actuality and animation films made by Thomas Horgan, in its Youghal Tribune *Collection.*

PROVENANCE:
Acquired from Mr. Jim Horgan; 1990.

RESTRICTIONS:
Copyright by Mr. Jim Horgan.

Actor, Noel Purcell, signing his autograph on the set of Moby Dick. (Horgan Collection. R.28,879)

■ **Brian Hughes Photograph Collection**

1980-1996
ca. **600 photographic prints**

ACCESS:
PC96 Lot 7. Surrogates available for reference in 6 folders.

RESTRICTIONS:
Copyright held jointly by Brian Hughes and the National Library.

PROVENANCE:
Acquired from Brian Hughes; 1990-1996.

Professional photographer Brian Hughes has documented daily life in Belfast since 1980. The National Library's collection is a sample of that visual record, principally street scenes and daily public activity in modern Belfast as well as elsewhere in Ulster. In addition, a group of images shows political murals of the period. Subjects also include: Sinn Fein Building, Falls Road; Queen Victoria, City Hall; Clonard Monastery, off the Falls Road; roadside flag sales, Shankill Road; Ulster Freedom Fighters mural, Newtownards Road. Most prints in the collection are black-and-white; the images of murals are colour prints. Prints are captioned and dated by the photographer, and include the photographer's reference number. Items are marked: Copyright Brian Hughes Photography. This collection is being developed.

Ulster mural: U.V.F. still defending Ulster, Newtownards Road, Belfast, 1996. (Brian Hughes Collection, Ref. no. 020719. Trans. 106)

This album contains portraits of accused and convicted criminals involved in the Phoenix Park murders (the "Invincibles"), the "Maamtrasna Massacre", and several other murders of the same period. The collection was compiled by J.J. Dunne, whose nom-de-plume was Hy Regan. This collection documents political prisoners and also shows the Victorian era's fascination with criminology. The album is a typical leather-bound carte-de-visite album with metal clasps.

The Irish National Invincibles emerged during the Land League activities of 1881. They assassinated the Chief Secretary Lord Frederick Cavendish and his under-Secretary Mr. Burke on 6 May 1882. Five were hanged for these Phoenix Park murders. The organization then disappeared. While active, the Invincibles were condemned by Charles Stewart Parnell, but had support from a few extremists in Ireland and the United States. Persons associated with the Phoenix Park murders and depicted in this album include: victim Lord Cavendish and his wife Lucy, Joe Brady, Michael Fagan, Timothy Kelly, Dan Curley, Pat Delany, James Fitzharris ("Skin-the-Goat"), and James Carey.

The so-called Maamtrasna Massacre of 18 August 1882 took place in a remote area of Co. Galway; murdered were five members of the Joyce family. Of ten men arrested, two became witnesses for the crown, five were given penal servitude for life, and three—Patrick and Myles Joyce, and Patrick Casey—were executed. Images of these three are in the album, as well as John Casey, Michael Casey, Thomas Casey, Martin Joyce, Thomas Joyce, and Anthony Philbin. The surname Joyce was common in the area.

Other defendants in related criminal cases depicted are: the Field case: Dan Delany, Joe Brady, Michael Kavanagh, Tim Kelly, James Mullett, and Hanlon; the Seville Place murder: Joe Poole, and Lamie; the Lough Mask murder: Patrick Higgins, Michael Flynn, and Thomas Higgins.

"Invincibles" Album

1882
1 album : 47 photographic prints (cartes-de-visite)

ACCESS:
Album 40.

RELATED PUBLICATION:
Waldron, Jarlath. Maamtrasna—The Murders and the Mystery. *Dublin: Edmund Burke, 1992. Corfe, Tom. The Phoenix Park Murders. London: Hodder & Stoughton, 1968.*

PROVENANCE:
Acquired from Lieut.-Col. Armstrong, grandson of the collector.

Two of the five men sentenced to death for the 1882 Phoenix Park murders. (Invincibles Album. Trans. 107)

'Quirke's Castle', south of the Main Street, Cashel. A surviving mediaeval town house. (Dean Wyse Jackson Collection. No. 52)

Noted maritime historian Dr. John Evan de Courcy Ireland (b. 1911) was one of the founders of the Maritime Museum in Dun Laoghaire. He travelled and lectured widely in support of marine subjects in Ireland and worldwide; this collection reflects his documentation of that vigorous activity. The snapshots, many in colour, record his own travels, focusing especially on maritime subjects, including: ferry crossings; harbours; ships including trawlers, liners, cargo ships, ferries, and topsail schooners. Ports of call include Dun Laoghaire, Liège, Marseille, Tunis, the Greek Islands, Algiers, and Dubrovnik, among many others. Some of the images, arranged in small notebooks functioning as albums, depict land travel and sites, and family and colleagues. The albums have been carefully assembled and images captioned by the donor.

■ **Dr. John de Courcy Ireland Photograph Collection**

1950-1990
59 albums : *ca.* 4500 photographic prints

ACCESS:
Albums are held in the Manuscripts Department.

PROVENANCE:
Gift of Dr. de Courcy Ireland; 1993; MS acc. 4746.

Dean Robert Wyse Jackson (1908-1976) was a Church of Ireland bishop and a writer. Ordained in 1935, he was made Dean of Cashel in 1946, and Bishop of Limerick, Ardfert, and Aghadoe in 1961. He also published widely, producing several books on local history, law, and Jonathan Swift, as well as two novels and a play.

The collection represents an unpublished work entitled "Photographic Survey of Cashel, 1948, by Major Keane and Dr. Jackson."

Probably taken by Major Keane, and assembled by Dean Wyse Jackson, the amateur photographs survey the archaeology, architecture, and topography of Cashel, Co. Tipperary. Each print is mounted on a separate sheet (*ca.* 10" x 8") and captioned. Subjects include, for example: the Deanery, the Diocesan Library, John Street, the Charter School of 1747, and 13th-century Hackett effigy in city wall in St. John's.

■ **Dean Wyse Jackson Photograph Collection**

1948
85 photographic prints mounted on paper

ACCESS:
By personal application.

PROVENANCE:
Gift of Dean Wyse Jackson; 1949.

■ **John Joly Slide Collection**

1890-1900
306 glass lantern slides, plus
colour screens

ACCESS:
*Accessible to staff only. Descriptions
are available in a detailed catalogue
of Joly slides, by Stephen Coonan
(volume 2 of his thesis, cited below).
It describes each of the 676 slides in
11 institutions that Coonan has
received permission to describe.
The first 306 slides constitute the
National Library's collection.*

RELATED MATERIALS:
*Coonan, Stephen. "The Discovery
and Evolution of Single-Image
Additive Colour Photography". A
thesis submitted to the Faculty of
Science, in candidacy for the degree
of Master of Literature, The
University of Dublin [Trinity
College], Department of Pure and
Applied Physics; and v. 2: "The Joly
Lantern Slide and Colour Plate
Register". Dublin: October 1989.
Unpublished.*

Professor John Joly (1857-1933) experimented with colour photography in Dublin in the 1890s. Born in Co. Offaly, John Joly was a relative of Jasper Robert Joly who played a crucial role in founding the National Library of Ireland. After graduating from Trinity College, Dublin, in 1882, John Joly was employed in the Physics Department. In 1897 he was appointed Professor of Geology, and continued to teach until his death. He published and lectured widely during his career.

While in the Physics Department at Trinity, probably in the early 1890s, he experimented with single-image colour photography, and was granted a patent for the process in 1894. During the period 1868-1903, he applied for over 40 photography-related patents in the United States, the United Kingdom, and France. In 1895, he exhibited colour photographs at the Royal Dublin Society, of which he was a Fellow and later President. The Joly method produced the first tangible colour transparency which could either be viewed in the hand or projected using an unmodified slide projector, according to recent thorough research by Stephen Coonan of the Dublin Institute of Technology. Joly's colour photography method was rendered obsolete by the discovery of the autochrome process in Paris in 1904 by Louis Lumière.

Many of the slides in the National Library's collection depict botanical subjects. Other notable subjects are: Irish landscapes and structures (e.g., Dartry Dye Works, Packhorse Bridge); portraits of Joly's lifelong friend and TCD colleague H.H. Dixon; parrots; printed advertisements and Japanese prints; still lifes with plates, drinks (e.g., Bass ale), and food; and photographs of slides taken through a microscope. Almost half of 676 original Joly colour slides extant are in this National Library collection. Other institutions holding Joly material are: Science Museum, London; Photographic Society of Ireland; Trinity College Physics Department; and Birr Scientific Heritage Foundation.

Early colour experimentation in a still life of arum and anthuriums. (Joly Collection. Lantern sld no. 27, Coonan register #282. Trans. 108)

Keogh Photograph Collection

1914-1950; bulk, 1914-1923
232 glass negatives (5.5" x 4.5")

ACCESS:
On-line catalogue records are available for all items in this collection, accompanied by images. Also, a reference aid in the form of a bound volume entitled "Checklist of Keogh Photographic Plates in the National Library of Ireland, March, 1971" provides alphabetical subject access, negative number and brief description. Negatives are accessible to staff only.

PROVENANCE:
Acquired from Brendan Keogh of Keogh Brothers; 1959.

Brendan Keogh (b. 1887) was principal photographer at the commercial firm of Keogh Brothers. Established in 1909, the firm operated at 75 Lower Dorset Street, Dublin, as "premier photographers and picture framers". By 1930 it had expanded to an additional location at the prestigious address of 124 St. Stephen's Green, and continued in business through 1958.

This is a selection of negatives created by Keogh Brothers. Images depict incidents during the 1916 Rising, the 1917 elections, and the Civil War, 1922-1923. Also included are many portraits of personalities of the period. Subjects most heavily represented are: 1917 elections in Co. Clare and Co. Kilkenny, the Easter Rising in Dublin, Fianna Éireann, Michael Collins, Éamon de Valera, and Countess Constance Markievicz. While relatively small, this is an accessible and well-used collection.

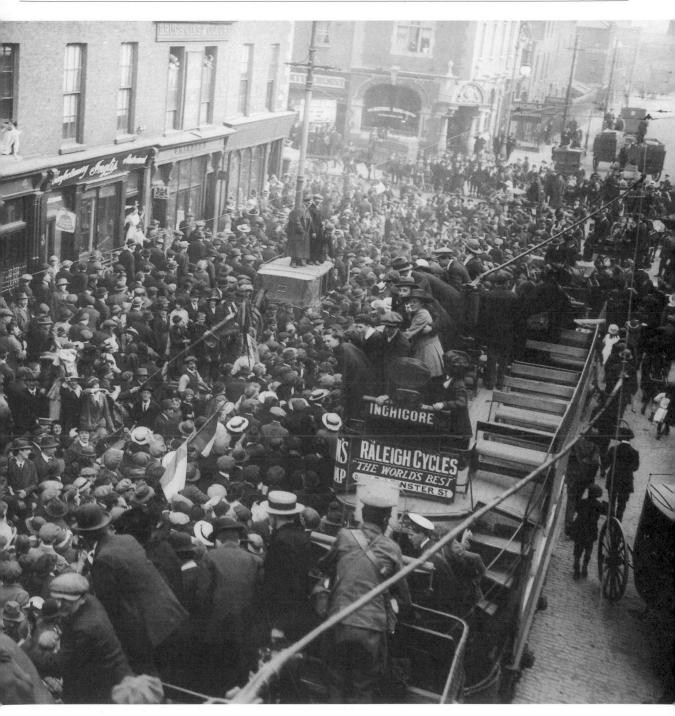

Supporters at the release of prisoners, Westland Row, taken from the elevated vantage point of the railway bridge, 1917.
(Keogh Collection. Ke. 125)

■ **Harry Kernoff Photograph Collection**

1912-1970; bulk, 1935-1960
45 photographic prints

ACCESS:
PC97 Lot30.

RELATED COLLECTIONS:
A number of Kernoff's woodcuts are in the Library's Prints and Drawings Department.

PROVENANCE:
From the papers of Harry Kernoff; 1981; MS acc. 3875.

RESTRICTIONS:
Press photos require permission to reproduce.

Dublin painter and printmaker Harry Kernoff in his studio, *ca.* 1960. (Harry Kernoff Photograph Collection. R. 28,194)

Born in London, Harry (also known as Aaron) Kernoff (1900-1974) moved to Dublin in 1914, studied at the Dublin Metropolitan School of Art, and won a scholarship in 1923. He exhibited at the Royal Hibernian Academy (R.H.A.) from 1926 and was elected to membership in 1936. Beginning in the 1920s, he participated in a loose group of writers and artists, including Maurice McGonigal and Seán Keating, who met to debate society and the arts, looking both to Europe and to the west of Ireland for inspiration in their developing work.

Kernoff produced woodcuts and oil paintings, principally but not exclusively portraits, and exhibited at the R.H.A.

every year after 1936. In the 1950s he began painting small canvasses (6" x 8"), producing hundreds of small oils. He exhibited in Paris, Chicago, Amsterdam, Toronto, Glasgow, and New York; in 1958 he painted in Nova Scotia, Canada.

Images in this collection span Kernoff's career. Included are photographs of Kernoff with friends and other artists at exhibition openings; in pubs including the Palace Bar in Dublin; in his studio with his paintings, including "The Turf Girl"; with the R.H.A. Selection Committee; on holiday. Some images may have been published as they bear on verso the stamps of Irish Times, Independent Newspapers, or Irish Press, Ltd.

High St., Kilkenny, from the Monster house (Duggan's) taken on 3rd June 1946 by Crawford. (Kilkenny Architectural Photograph Collection. Kilkenny No. 800/5)

■ **Kilkenny Architectural Photograph Collection**

1946
107 photographic prints (6 x 5 cm.), plus corresponding negatives

ACCESS:
A reference aid comprising photocopies of the images and an index ("Mr. O.G.S. Crawford's Kilkenny Survey, May 31-June 7, 1946") is available. Original prints are accessible by personal application.

RELATED PUBLICATION:
Butler, Hubert. "A Kilkenny Survey", in Old Kilkenny Review, *1946-47. No. 1 (January 1948), pp. 31-33.*

RELATED COLLECTION:
Dean Wyse Jackson Photograph Collection.

PROVENANCE:
Negatives were gift of Hubert Marshall Butler; 1946; prints were purchased in 1994.

In 1945, Mr. O.G.S. Crawford, then editor of *Antiquity* magazine, visited Kilkenny to lecture to the Kilkenny Archaeological Society, which had been recently revived by noted essayist Hubert Marshall Butler (1900-1991) of Bennetsbridge, Co. Kilkenny. Crawford was impressed by the town's historical architecture, but saw that post-war modernisation and road-building would obliterate surviving traces of Kilkenny's past, and that a photographic survey should be undertaken. After a competition for the job of recording the survey turned up no ideal surveyor, Crawford himself returned to carry out a photographic survey of Kilkenny for ten days in June 1946. Butler said of him: "He must have been the first English visitor to ascend the yellow turret of the Monster House." Butler hoped that the Kilkenny survey would inspire similar surveys in other historic towns.

This material is a photographic survey of buildings and architectural details of Kilkenny city and surrounding area. The photographs were taken between May 31 and June 7, 1946. The materials were organised by Mr. Butler. Subjects include street scenes and details of architectural interest, such as: the house at the corner of Irish Town and Dean Street; well-head, Rothe's Court, 1604; and St. Mary's Churchyard, Butler Monument, 1773.

■ **Kilronan Albums**

1858
1 album : 106 photographic prints (salt prints), plus 100 corresponding paper negatives (calotypes)

ACCESS:
ALBUM 1, ALBUM 2 An item level index of images featured in the Kilronan Album is available for reference.

PROVENANCE:
Albums were acquired from the family ca. 1941.

These albums are sometimes referred to as the Tenison albums. The images are family photographs and views taken by Louisa Tenison and her husband Edward King Tenison, of Kilronan Castle, Co. Roscommon. Both Louisa and Edward were amateur photographers. They acquired one of the few licences from the British photographic pioneer and originator of the paper negative, William Henry Fox Talbot, and used this negative-positive process (as opposed to the one-off daguerreotype

process) in their amateur photography. The salted paper prints have their corresponding paper negatives (calotypes). It is unknown which materials were created by which photographer, however many of the salt prints bear the initials EKT in the bottom right corner.

Many of the salted paper prints in this large and well preserved collection include country houses, situated in the midland area, as well as in counties Mayo and Galway. Subjects include

topographical views of and near Kilronan Castle, including the gate house and entrance to Kilronan Castle and the nearby Lough Meelagh and Kilronan Church. Also included are Melcombe House, Killala, and the Rockingham estate, Boyle and other smaller country houses in Charlestown, Jamestown and the Carrickglass Manor just outside Longford town.

There are some slightly later albumen prints of popular Dublin sights, featuring Royal Hospital, Kilmainham, the Rotunda Hospital and in County Dublin, Malahide Castle and the beautiful stone roofed church of St Doulagh's in Kinsealy.

Having been kept in an album, the salt paper prints are in good condition. The corresponding calotypes, which until recently were not carefully housed but loose, are in remarkably good condition, reflecting perfectly Talbot's nomenclature calotype, from the Greek kalos, meaning beautiful, and the Latin typus, meaning image.

These early images of Grania Maile's Castle, Clare Island are the calotype (left) and the corresponding salted paper print (below) by Edward Tenison; note his initials EKT in the lower left hand corner. (Kilronan Album Collection. Trans. 117(Calotype) and Trans. 116(Positive))

■ William Lawrence Photograph Collection

1865-1914
40,000 glass negatives divided into groups by size
***ca.* 15,000 photographic prints**
***ca.* 500 printing blocks for the postcard series**

ACCESS:
Reference aids are available for all of the images. The bulk of the collection can also be viewed on microfilm, excepting the New Series material. While the quality of the film has deteriorated over the years as a result of very heavy usage it remains a useful surrogate for viewing the collection prior to ordering copy prints. The prints and printing blocks are only available by personal application.

The glass negatives are arranged in original numerical sequences, within four different-size groups. The Imperial size is 12" x 10" and numbers approximately 4,500. The Royal size, 8.5" x 6.5", comprises 13,000 plates, and the Cabinet size, 7.5" x 5", totals approximately 10,000. The New Series comprises all plate sizes and numbers about 10,000 plates.

RELATED COLLECTIONS:
Lawrence Photographic Project Collection (1990). See also Various Photograph Albums.

RELATED EXHIBITS:
"Fadeographs of a Yestern Scene," National Photographic Archive (Temple Bar), 1996.

RELATED PUBLICATIONS:
Hickey, Kieran. The Light of Other Days. *London: Allen Lane, 1973. Chandler, Edward and Walsh, Peter.* Through the Brass Lidded Eye: Photography in Ireland, 1839-1900. *Dublin: Guinness Museum, 1989.*

PROVENANCE:
Purchased; 1943.

The Lawrence collection remains the most popular source of photographic material in the National Library. More has been written on the Lawrence photographs than on any other commercial collection of 19th-century Irish photographs. Since its acquisition in 1943 it has exemplified the richness of the Library's photographic collections and copy prints are seen throughout the country, having been sold extensively.

The primary subject coverage is topographical views throughout Ireland. Many of these either include people and activities that give depth and information of value to the views. Some focus on people, activities, and interiors more than on topography. Images taken in the National Library's Reading Room are a good example of the Lawrence images focusing on people and interiors. The result is a most comprehensive social document between c.1880 and c.1915.

William Mervyn Lawrence (1840-1932), an entrepreneur, recognized photography's commercial potential. In 1865 he opened a photographic studio in his mother's fancy-goods and toy shop, well situated opposite Dublin's General Post Office in Sackville Street, now O'Connell Street. He employed a portrait photographer whose name is unknown and began taking over from his brother John Fortune Lawrence the business of producing and selling stereographs to feed the popular craze of the time. He also acquired original negatives from Dublin commercial photographer Frederick Holland Mares; approximately 300 of the earliest glass plates in the cabinet series were taken by Mares in the mid-1860s.

Ultimately, William Lawrence's thriving business employed photographers, printers, colourists, and retouchers, as well as sales personnel. By 1880 the cumbersome wet-plate collodion process gave way to the dry-plate process, and cameras having become smaller and lighter and therefore more portable the company expanded its work to include a range of topographical views of Ireland. Most of these photographs are credited to Lawrence's employee Robert French who had worked his way up to the position of chief photographer. French, born in

Dublin in 1841 and having previously been in the employ of the Royal Irish Constabulary, began working in the Lawrence studios in the early 1860s. He probably took about 30,000 of the National Library's 40,000 negatives. Specialising in the outdoor views, he captured images of virtually every small Irish village.

From the 1890s through 1902, Post Office regulations began allowing correspondence not in envelopes and with images on one side. This enabled Lawrence's photographic postcards— scenic views of Irish tourist spots and urban views—to become quite profitable. By the turn of the century the Lawrence studios were among the largest in Dublin and with their prestigious premises on the city's main thoroughfare, business thrived. The economic boom throughout Europe in the first decade of the 20th century allowed the photographic studio business to develop at a phenomenal rate. A further important factor in the industry was the impact of popular tourism and its associated paraphernalia—postcards, souvenirs and viewbooks. William Lawrence, an astute businessman, marketed his products well and in a timely fashion always conscious of the importance of keeping up to date in such fast changing environment. The Emerald Isle Series of booklets, depicting city and county beauty spots, were produced by Lawrence; examples are held in the Album collection.

Ironically, it was the very popularity of photography that contributed to the demise of the Lawrence studios. The appearance of the Box Brownie in the last decade of the 19th century allowed amateur photographers to capture their own views, of family, friends and holidays. Other developments on a general level also doomed the Lawrence business: the movies began to eclipse still images, and the onslaught of the First World War curtailed lucrative German business links that Lawrence had forged.

However, it was events closer to home that caused most damage to the business. The prolific photographer Robert French left the firm in 1914 and Lawrence himself retired in 1916; the business was forced

onto his youngest son William. None of Lawrence's large family had previously worked in the business so it was perhaps inevitable that the same business success would not be carried on to the next generation. William's inheritance was short-lived: within weeks of taking over the business the rising of 1916 occurred. This resulted in the destruction of the portrait negatives which were housed in the Sackville Street premises as these were almost directly opposite the GPO and the Lawrence shop was among the first to be looted. Fortunately, the glass plate negatives of outdoor views were stored in Rathmines, and so survived. The company continued to operate under the Lawrence family's ownership for a further quarter of a century. There are some

photographs of Dublin rebuilding following the damage done during the Rising and subsequent events, but they are a shadow of previous work both in quantity and quality.

The firm finally closed in December 1943 and the toy and fancy shop with contents was put up for auction. This may have enabled the glass plates to be used in greenhouses due to the wartime shortage of glass. The National Library purchased the entire remaining collection for £300, a wise investment indeed.

For more details on the collection, Kieran Hickey's book listed above is a scholarly work on the collection and the two individuals associated with it, namely William M. Lawrence and the photographer, Robert French.

An unusual view of Killarney, the Cooperage area showing casks and barrels in the making, *ca.* 1890. (Lawrence Collection. R. 9,985)

This magnificent collection has become the great strength of the photographic collections in the Library, in part due to the well organised, comprehensive indexes that accompanied this commercial collection.

The collection is divided into four main sections by size of the glass plates: Cabinet (9"x 7"), Imperial (12" x 10") and Royal (10" x 8"), as well as the New Series section which is comprised of various sizes of what were considered by Lawrence to be of imperfect quality. These "seconds" were indexed separately from the rest of the collection. Copper photomechanical printing blocks for printing postcards are also included as a supplement to the photographic negatives. There are also a large number of photographic prints which were obviously still being marketed until the business closed.

The Lawrence collection has been reproduced in many historical and photographic works. The images are often associated with James Joyce's literary works due to the collection's visual details of Dublin at the turn of the century. The Library has exhibited a photographic and Joycean celebration of life in Dublin entitled "Fadeographs of a Yestern Scene" which brings together the visual and literary contexts.

The Round Tower, Armoy, Co. Antrim as taken by Robert French of the Lawrence studios in the 1880's. (Lawrence Collection. R.3,506)

These images are views roughly corresponding to those taken between 1870 and 1910 by the firm of William Lawrence, mainly by Robert French. This re-photographing project was undertaken by 77 professional and amateur photographers in the Federation of Local History Societies and the Federation for Ulster Local Studies. The project was sponsored by Fuji (Ireland) Limited and the National Library of Ireland. The images, following a selection of original Lawrence images, were made to document the changes in the Irish landscape in period between 1870/1910 and 1990, and to graphically preserve the terrain in light of future changes. Scenes were selected on the basis of perceived significance, emphasis on street scenes, and geographical spread. Two reasons for inexact matching of modern views with the Lawrence images were bad weather, and difficulty in reaching the identical vantage point as the Lawrence images. Some scenes were closely matched, as in the case of photographer Sean Casey of Dundalk who, in replicating an image with a woman in the foreground, identified the woman and located her granddaughter whom he included in the 1990 image.

■ **Lawrence Photographic Project Collection**

March-December 1990
1019 photographic prints (colour), plus colour film negatives and contact prints

ACCESS:
By personal application. The project's published catalogue, Lawrence Photographic Project 1990/1991, *provides access by county and specific place (e.g., Longford, St. Mel's Cathedral), and includes a project reference number, photographer, date taken and corresponding original Lawrence number.*

RELATED COLLECTIONS:
William Lawrence Collection; Our Own Place Photographic Project Collection.

RELATED PUBLICATIONS:
Lawrence Photographic Project 1990/1991: a retrospective addition to the Lawrence Collection in the National Library of Ireland: Catalogue. *Sponsored by Fuji Ireland Limited. [Kilkenny]: Federation of Local History Societies, [1991], 71 pp.*

PROVENANCE:
Gift of the Federation of Local History Societies and the Federation of Ulster Local Studies; 1991.

RESTRICTIONS:
Copyright held by the National Library of Ireland.

A contemporary view of the Round Tower, Armoy, Co. Antrim; photographed by Cathal Dallat, from Ballycastle, Co. Antrim. (Lawrence Project 1990. Colour— 6A/18)

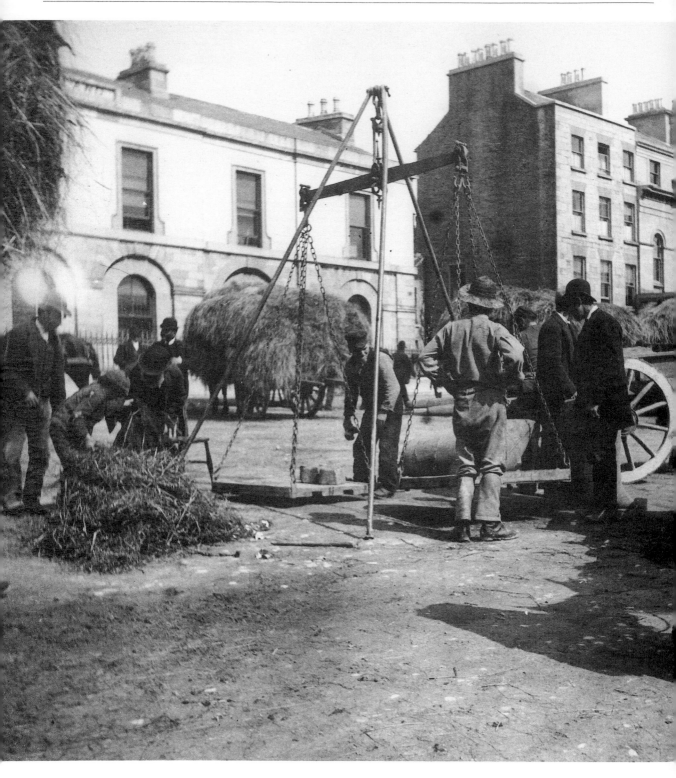

These images depict life in the last decade of the 19th century in three locales, Galway, Dublin, and Kilkee, Co. Clare. The majority are images of Galway, for example, masted ships at the quay and the harbour master's office, the poultry and hay marketplace, and various local men, women and children.

The Dublin images show the burnt-out ruins of Arnott's department store in Henry Street with onlookers; and a parade in Dublin on an anniversary of Parnell's death, showing the Lord Mayor's coach, soldiers or sailors marching, a group of boys, and crowds of men.

Also included are scenes in Kilkee, Co. Clare, of a street circus, and wooden huts used in 1890s sea-bathing. The prints are 10" x 8" copy prints. It is not known whether Levingston was the photographer or the collector.

■ Levingston Photograph Collection

1893-1894
50 glass lantern slides, plus corresponding copy prints and copy transparencies

ACCESS:
A reference aid comprising copy prints is available for researchers. Images are arranged under four topics: Galway docks and marketplace; Arnott's in Dublin; parade; Kilkee. Each image is indexed in "Places" card catalogue for copy negatives.

PROVENANCE:
Acquired ca. 1990; printed from original material on loan from Kennys Bookshop, Galway.

Hay market in Galway City, 1893. (Levingston Collection. R. 26,753)

■ **Luftwaffe Photograph Collection**

1940
16 photographic prints (copy prints, 12" x 16")

ACCESS:
By personal application.

PROVENANCE:
Purchased; 1994.

The Republic of Ireland was neutral during the Second World War (1939-1945). However, Dublin was bombed by the Luftwaffe in May 1941, apparently by mistake. Thirty-four people were killed on the North Strand.

This is a collection of modern copy prints of German aerial reconnaissance photographs of Dublin and environs, dated 29 December 1940. Views are identified and include Collins Barracks, McKee Barracks, Keogh Barracks, Griffith Barracks, the gasworks. The scale is 1:9.5000. Prints are marked: "Available from Nigel J. Clarke Publications."

■ **Michael MacConnoran Album**

1922
1 album : 17 photographic prints (copy prints)

ACCESS:
Album 161. Photocopies are available in a reference aid in the Photographic Department.

PROVENANCE:
Gift of Desmond MacConnoran, New York City; ca. 1985.

Amateur photographer Michael MacConnoran (1878-1944) took the photographs (of which these are modern 10" x 8" black-and-white copy prints) from or near 6 Lincoln Lane, Arran Quay, Dublin, in 1922. The album includes a modern title page: "In memory of Michael MacConnoran, 1878-1944. This collection of 17 amateur photographs ... has been donated to the National Library of Ireland." The photographs are captioned and numbered, and include a photographer credit to MacConnoran. The album also includes a hand-drawn map of Dublin marked with "positions from where pictures were taken". (Note: Thom's Directory of 1921 and 1922 does not list a Michael MacConnoran as living in Dublin.)

Irish Linen Trade Roughing Flax, York St. Mill, Belfast. (Mason Collection. R. 28,444)

Between 1880 and 1964, Thomas H. Mason, and later Thomas H. Mason & Sons, Ltd., operated at 5-6 Dame Street, Dublin, as opticians and photographic dealers. These slides from that firm are a wide-ranging set of historical images—not all photographs—that were used to educate audiences as to notable places and people in Ireland's history.

Most of the slides are not original images, but copied from commercial studios. They are organised topographically (primarily by county), 40 slides fitting within each box. Many depict ecclesiastical buildings and notable architectural views. Other groups were records of Irish history back to the Normans, with one set of slides containing popular images of Daniel O'Connell and another of pictures associated with Father Theobald Matthew and the Temperance League. Yet others depict Irish saints, such as Saints Patrick, Columba and Aiden, and places associated with them, e.g., Croagh Patrick. Many images are copies of drawings and prints reproduced from books. The last but not least group of slides is images of various Irish industries of the turn of the century, including the linen, brewery and flax industries.

■ **Mason Photograph Collection**

1890-1910
ca. 2,300 **glass lantern slides**

ACCESS:
Slides are accessible to staff only.

■ Tim Maul Photograph Collection

1980-1990
14 photographic prints : colour (Cibachrome, 16" x 21")

ACCESS:
By personal application.

PROVENANCE:
Purchased from Tim Maul; 1996.

RELATED EXHIBITION AND PUBLICATION:
Exhibited at Betsy Senior Gallery, New York, January-March 1996. Also, an article in Circa *magazine, Summer 1996.*

The National Library of Ireland on Kildare Street in Dublin was designed by Thomas Deane after sketches by William Archer, the Librarian from 1877 to 1895. Built by Messrs. Beckett of Ringsend, it opened in 1891. Almost a century later, its interior has been artistically documented in these photographs by Tim Maul, a professional photographer from New York. The photographs show the small-scale and commonplace, including books on shelves, plasterwork in the Reading Room, and the printed books catalogue volumes. They "reveal the artist's talent for poeticizing the familiar," according to a description of an exhibit of these works.

Detail from a literary stained glass window in the National Library. (Maul Collection. Trans. 194)

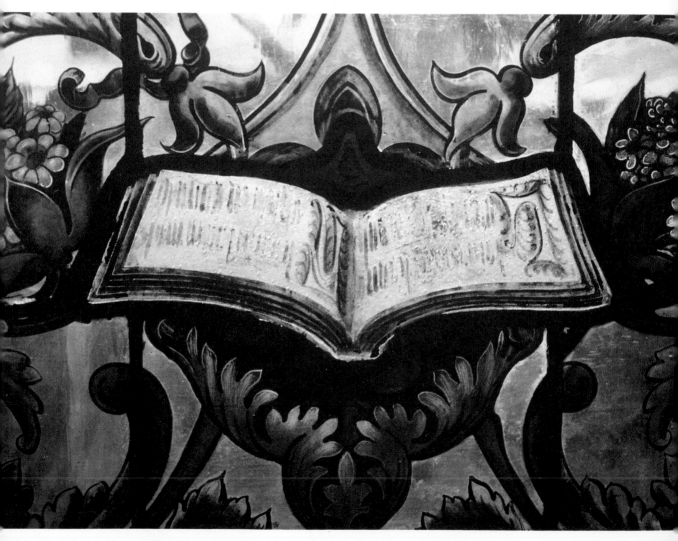

Ranging from the mid-19th century almost to the present, this material includes a wide variety of photographs, roughly grouped by person, place, event/date and subject. Each grouping ranges from 1 to as many as 100 items. Most groups were constituted in 1994 and 1995 from unsorted materials, and are largely without a documented source. New groupings continue to be created as further sorting continues. These subject groupings are maintained as part of the Library's holdings in addition to the named collections. Categories were devised as needed, thus reflecting the actual holdings.

The largest number of groups is to be found under names of persons notable in politics, literature and the performing arts, such as: Cathal Brugha, Sir Roger Casement, Winston Churchill, Michael Collins, the 'Cuba' Five (Fenian prisoners deported to the U.S. in 1871 on the ship 'Cuba'), Éamon de Valera, John Ford, Canon Hurley, Countess Markievicz, Cyril Potter, John Redmond, George Bernard Shaw.

Other subjects are general topics and formats, including: Irish stage actors and actresses; clergy; religious prints; government buildings; railways; ships; British royalty; Civil War personalities and scenes; sport; fishing/angling; postcard views of Dublin, 1916 and 1922; theatre/concert flyers; modern architecture; advertising posters and photos for films. Events and activities categories include: Royal visits to Ireland in 1901 and 1911, the Leopardstown races, the 31st Annual Eucharistic Congress 1932, Imperial Conference 1921, Cork International Exhibition 1903. Further groups are collected under names of places and institutions, such as St. Audoen's Church, Milltown Park House.

■ Miscellaneous Photographs Collection

1860-1990
ca. 10,000 **photographic prints**

ACCESS:
Each subject group has an entry in the Department's card catalogue. While the card indexes are currently (1997) available only to staff, increased public access to this valuable source of information is expected.
Some high-demand groups have photocopy surrogates organised for ready reference use by staff, and available for researchers by appointment. These include: Evictions; Civil War (1922); Easter Rising (1916); and Irish life.

PROVENANCE:
Acquired from various sources from the founding of the Library in 1877, with the bulk coming after 1950. Some were purchased, others were gifts, and in addition many were acquired with manuscript collections.

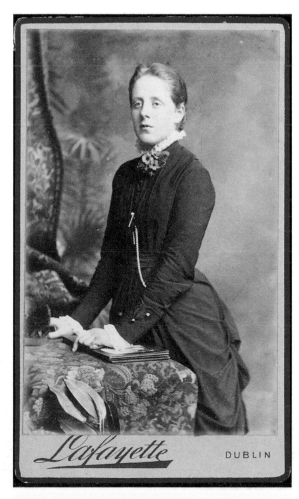

Carte-de-visite portrait, *ca.* 1880, by Lafayette of an unidentified young woman. Despite the small size this albumen print shows great detail. (Chandler Collection. Trans. 109)

■ **Morgan Aerial Photograph Collection**

April 1954-May 1957
2,831 film negatives (4" x 5")

ACCESS:
An item-level finding aid was completed in 1996. Access is alphabetical by "View"—by county, then by town or place. Photocopies are available for some images.

PROVENANCE:
Purchased from Mrs. Alexander Campbell Morgan; 1991.

These aerial photographs were taken by pilot and commercial photographer Captain Alexander Campbell "Monkey" Morgan (1920-1958), who traded under the name of Aerophotos. Many images were published in the Irish Independent in a weekly "Views from the air" series in 1957. The very next year Morgan was tragically killed at the age of thirty-eight when his twin-engine Piper Apache aircraft crashed near Shannon Airport in January 1958. Morgan was carrying photographs of a hotel disaster in Ennis by another photographer to Dublin to be transmitted to Manchester.

Morgan had been a reconnaissance pilot with the Royal Artillery during the Second World War, and was awarded the Distinguished Flying Cross. After the war he moved to Dublin where he operated a charter flying and photography business. He was regarded as one of the best post-war light aircraft pilots in Ireland.

This interesting collection comprises medium- and low-altitude black-and-white aerial views of places and events, many commissioned by clients including newspapers, builders, schools, and industrial concerns. Images depict places in almost all counties of the Republic as well as a number in Northern Ireland. This is an important collection for its breadth of subject coverage; the time period is not otherwise well-represented in the Library's holdings. The images show great detail.

Morgan's detailed photographer's log supplements the images, providing the location and date of each event photographed. This is keyed to the negative numbers. It includes information about the sale or use of each photograph. The log enables the collection to be studied as a commercial archive, complete with client list, transaction dates and other details.

■ **Richard Mulcahy Photograph Collection**

1906-1965; bulk, 1920-1940
***ca.* 300 photographic prints (copy prints, 4" x 5") plus corresponding copy film negatives**

ACCESS:
Reference prints and a subject index are available.

RELATED COLLECTIONS:
The Richard Mulcahy papers are in the collections of University College Dublin.

PROVENANCE:
Copied from original photographs on loan from Dr. Risteárd Mulcahy and Padraig Mulcahy, sons of Richard Mulcahy; 1991.

General Richard James Mulcahy (1886-1971) was a leading figure in the War of Independence from 1916 onwards. He supported the Treaty and was Army chief of the provisional government during the Civil War. He held various ministerial posts in the period 1923-57. A founding member of Fine Gael, he was leader of the party for the period 1944-59. A supporter of the Irish-language revival, he chaired the Gaeltacht Commission 1925-1926. He was twice Minister for Education between 1948 and 1957. He retired from politics in the early 1960s.

This is a collection of family photographs along with images documenting political affairs since just before 1916. Most photographs show members of Mulcahy's family, especially his wife Mary Josephine "Min" Ryan Mulcahy, his children, and his siblings including his brother Sam (Dom Columban); Richard Mulcahy's Rathmines family house (1922-1966), Lissenfield House; political friends and acquaintances including William Cosgrave and Mrs. Cosgrave, Michael Collins, Sean MacMahon, James Ryan, and others; military locations and events, e.g., Coosan Camp near Athlone, Michael Collins' funeral, IRA Dublin Barracks 1922; family holidays in Ireland (e.g., Achill Island and Carna) and elsewhere (e.g., Niagara Falls, N.Y.).

Above:
Aerial view of Howth
lighthouse, *ca.* 1956.
(Morgan Collection.
Morgan 1,365)

Left:
Maj. Richard Mulcahy
with Maj. Gen. Daniel
Hogan raising tricolour
over GHQ Park, Dublin,
in 1922. (Mulcahy
Collection. R.24,867)

England:
American women
condemn your
reign of terror in
the Irish Republic

Kathleen O'Brennan was a journalist and republican; her sister Áine O'Brennan Ceannt was the wife of Eamonn Ceannt. O'Brennan publicised the republican cause, wrote numerous articles on the subject, and lectured in the United States in the 1910s and 1920s on topics relating to Irish art and drama, as well as political subjects. This collection depicts aspects of her personal life and career. The bulk of the collection is portrait photographs, both studio and informal, of: herself; her sister Lily O'Brennan; Ninette de Valois; Mr. and Mrs. Jack London; Benito Mussolini; and others. It further includes eight press cuttings reporting O'Brennan's cultural talks to drama clubs and at Mills College, a women's college in California, in 1916, 1917, and 1921; her press pass as a member of the Winnipeg (Canada) Free Press to a Sinn Fein Ard Fheis in 1922 in Dublin; and 20 commercial postcards of Salzburg, Austria.

Woman carrying banner and American policeman ticketing, *ca.* 1920. (O'Brennan Collection. R. 28,196)

■ **Kathleen O'Brennan Photograph Collection**

1916-1930
120 items, including 92 photographic prints and 28 printed items

ACCESS:
PC97 Lot26.

PROVENANCE:
From the papers of Áine Ceannt; various years.

Photographer Alan O'Connor studied art history and photography at college in Dublin. His work has been recognised by various institutions, including the National Library, which commissioned over 80 photographs to complement the text of Colm Lincoln's book *Dublin as a Work of Art* (1992). The Library's collection of O'Connor's works includes prints of these black-and-white photographs depicting Dublin's cultural diversity, as well as others documenting life in Temple Bar, and images taken on a fishing trawler. The collection includes the original 35mm negatives for the Lincoln book's photographs. The images extend similar but earlier coverage by the Wiltshire Collection.

■ **Alan O'Connor Photograph Collection**

1990-1995
***ca.* 200 photographic prints, plus over 400 film negatives**

ACCESS:
By personal application.

RELATED PUBLICATION:
Lincoln, Colm. Dublin as a Work of Art. Dublin: O'Brien Press, 1992.

RELATED COLLECTION:
Elinor Wiltshire Photograph Collection.

PROVENANCE:
Purchased; 1990-1995.

With a crew of four, a trawler operates out of Arklow, Co. Wicklow. After the catch is sorted, the fish which are too small are kicked back into the sea through a small hatch. April-May 1993. (Alan O'Connor Collection. Trans. III)

■ **Fergus O'Connor Photograph Collection**

1890-1915
ca. **600 glass negatives**

ACCESS:
Accessible to staff only.

PROVENANCE:
Purchased; 1985.

Fergus O'Connor was a Dublin publisher, responsible for publication of Sean O'Casey's early writings, as well as nationalist postcards and similar materials. This material comprises 6" x 8" and 10" x 12" glass negatives dating from *ca.* 1890 to 1915. Subjects are views of places and activity throughout Ireland, such as Belfast, Dublin, Lurgan, and numerous images of Cork. Images include: the Roman Catholic chapel in Cork; the Phoenix Park Hotel, with an automobile parked in front; Guinness barges on the Liffey. The range, date, and type of views recall the much more extensive Lawrence Collection.

19th century tourists kissing the Blarney stone, (O'Connor Collection. O'Connor 77)

The O'Dea photographs document railway transport in Ireland from 1937 through 1966, when the railway was important in Irish life. James P. O'Dea (1910-1966), a nephew of the comedian Jimmy O'Dea, was a founding member of the Irish Railway Records Society in 1946 and a devoted railway enthusiast. He took all the photographs in this collection. Subjects include: locomotives and railroad cars, railway stations, bridges, staff and passengers. Images of many railway lines, equipment, and stations which no longer exist are included here. The occasional railroad disaster is also represented. A few non-railway transport subjects are included, such as ships, barges, and highways. In addition, an assortment of scenes in Dublin, such as the Nelson Pillar in March 1966 (after the Nelson statue was removed), and Guinness barges on the Liffey are included. A few historical events connected with railroad transport are documented here, notably Éamon de Valera's 1938 appearance at Westland Row after returning from negotiations in London regarding Irish ports.

Materials are arranged in the following groups:

Great Southern and Western Railway; includes Waterford, Limerick & Western
Midland Great Western Railway
Cork Bandon & South Coast Railway
Great Northern Railway (Ireland) (GNRI)
Cavan & Leitrim Railway
Northern Counties Committee (LMS NCC)
Dublin & South Eastern Railway (includes Harcourt St. line) (DSER)
Donegal Railways
Signal Boxes & Instruments
Lucan Tram, Drivers, GM Locos, Lanesboro
Sundry

■ James P. O'Dea Photograph Collection

June 1937-November 1966
ca. 4200 photographic prints and corresponding film negatives

ACCESS:
By personal application. There is a general description of the collection, and item listings of four of the above groups: GNRI (nos. 1 and 2), LMS NCC, Signal Box & Instruments, and DSER, including Harcourt St. line. This helpful document was created in 1993 by Ken Manto, railway enthusiast and member of O'Dea's organization, the Irish Railway Records Society.

PROVENANCE:
Purchased from Mrs. Mary Hayden, daughter of Mr. O'Dea; 1993.

At the scene of the Newbridge accident, 7 September 1962; Inspector P.W. Lally gesticulates in the foreground. (O'Dea Collection. No. 32/70)

■ **Dermot O'Dowda Photograph Collection**

1982-1991
27 photographic prints

ACCESS:
PC97 Lot42.

RESTRICTIONS:
Copyright by Dermot O'Dowda.

PROVENANCE:
Purchased from Dermot O'Dowda; 1994.

These photographs are by professional photographer Dermot O'Dowda. The collection provides a contemporary record of aspects of community life in Co. Kerry, Co. Cork, and Co. Donegal. Subjects include: Women's prison in Cork before 1991 refurbishment; shamrock sellers, Cork city, 1987; famine fields, Glanrastel, Co. Kerry, 1986; Dingle fleadh, Co. Kerry, 1980; fair day, Kenmare, Co. Kerry, 1986; Letterkenny festival, Donegal, 1982. All but five photographs are 10" x 8" colour prints.

A colourful scene on Fair Day, Kenmare, Co. Kerry, 1986. (O'Dowda Collection. Trans. 112)

J.W. O'Neill was an assistant engineer at the General Post Office, Dublin. The photographs in this album were taken by O'Neill in May 1916. They show the interior and exterior of the G.P.O. after the damage inflicted during the April 1916 Rising.

■ J. W. O'Neill Album

1916
1 album : 29 photographic prints

ACCESS:
Album 107.

PROVENANCE:
Purchased from F.C. Nolan, London; 1995.

The engine room in ruins, part of the damaged GPO interior, 1916. (O'Neill Collection. R. 27,975)

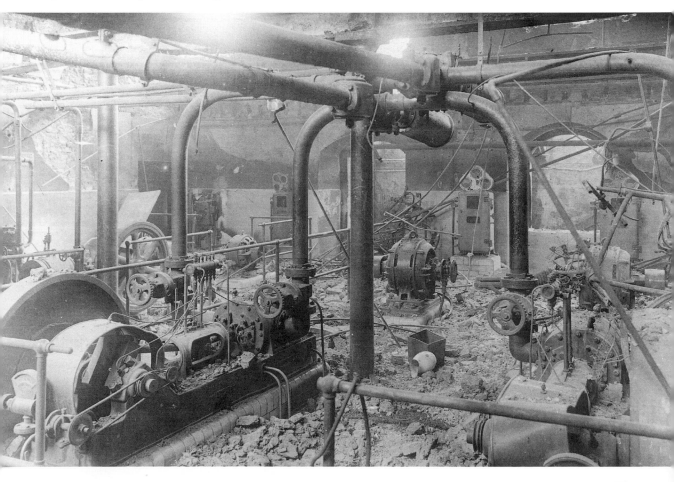

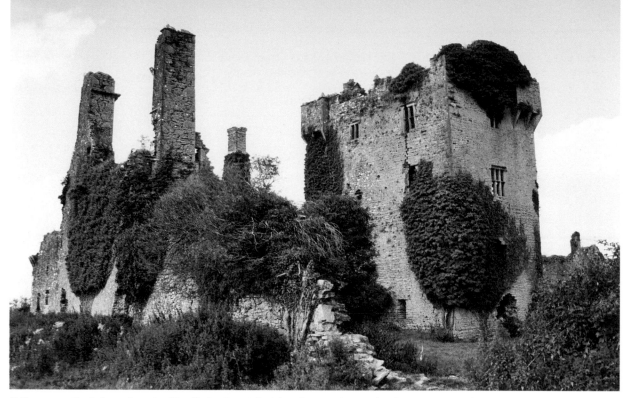

Ballygrennan Castle located south of Bruff, Co. Limerick. This photograph was taken by Mary Carty of Lough Gur and District Historical Society. (Our Own Place Collection. No. 20A/29)

■ **Our Own Place Photographic Project Collection**

1993-1995
700 photographic prints (colour), and corresponding film negatives

ACCESS:
PC96 Lot2. A printed finding aid and index provides access by the photographer and researcher's names, date, and place.

RESTRICTIONS:
Copyright by the National Library of Ireland.

RELATED PUBLICATIONS:
Our Own Place Photographic Project: an archive of photographs and text reflection life in Ireland to-day. Catalogue *[and]* Keyword Index. *Sponsored by RTÉ and Fuji Photo Film (Ireland) Ltd. [Kilkenny]: Federation of Local History Societies, in conjunction with The Federation for Ulster Local Studies, Belfast, [1996].*

This collection is described by the Federation of Local History Societies as "an archive of photographs reflecting daily community life in Ireland." A follow-up on the Lawrence Photographic Project, this collection of images is the product of a cooperative effort of local historical society members, the Federation of Local History Societies, the Federation for Ulster Local Studies, Fuji Photo Film (Ireland) Ltd., and RTÉ. Each of approximately 55 local history societies, with the help of as many photographers, chose subjects including street scenes, housing estates, schools, people at work, transport, people at church, entertainment, commerce, industry,

agriculture, shop fronts, people at home, and historic buildings. It provides a modern pictorial survey of life in Ireland, a modern complement to older collections with similar coverage in the Library's photographic archive.

The collection is sometimes known as the Federation of Local History Societies Collection.

An identical set of prints and negatives are held by the Ulster Museum in Belfast. Each participating local history society also holds materials on its own selection.

A reception to mark the donation of the materials to the National Library was held September 19, 1996 at the National Library.

RELATED COLLECTIONS:
Lawrence Photographic Project Collection 1990/1991; William Lawrence Photograph Collection.

PROVENANCE:
Gift of Federation of Local History Societies and Federation for Ulster Local Studies; 1996.

These albums contain early 20th-century panoramic views of coastal scenes around Ireland. Scenes have been taken from land as well as from sea. One album is titled: "Prints from Films Exposed in the Alvista Panorama Camera 1906." In most of the albums, the photographs are mounted two per page, in topographical order, beginning with the southwest coast of Ireland. Views include those from Inch Island, Skerries, Rosses Point, Belfast Lough, the light vessel *Lucifer*, Lambay Island, Fanad Point lighthouse station, Loop Head lighthouse. Each is captioned; for example: "Southwest coast of Ireland. View from gallery of Roancarraig Island lighthouse, looking in the direction of Sugarloaf Mountain. September 1905." The photographer is unknown, however it is highly likely that they were taken by a member of the Commissioners of Irish Lights while on coastal tours.

■ **Panoramic Photograph Albums**

1905-1908
6 albums : *ca.* 514 photographic prints (12 x 30 cm.)

ACCESS:
Albums 5, 6, 13, 21, 22, and 24.

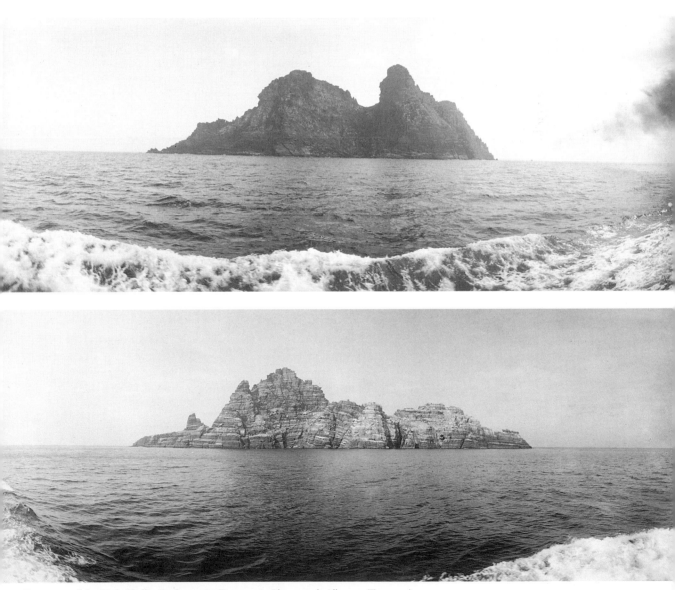

Panorama of the Little Skellig Rock, 1906. (Panoramic Photograph Albums. Trans. 113)

■ A. H. Poole Photograph Collection

1884-1954
ca. **65,000 glass negatives**

ACCESS:
Negatives are accessible to staff only. Subject and chronological access to the collection can be gained using the microfilmed indexes from the original order books. A selection of the 2,000 Imperial plates have been catalogued onto the Library's computer system to be accompanied by images.

PROVENANCE:
Purchased from members of the Poole family; 1954.

RELATED PUBLICATION:
Des Griffin. A Parcel from the Past: Waterford as seldom seen before. *Waterford: Intacta Print Ltd./Waterford Civic Trust, 1994. This work provides a selection of 51 captioned images from the Poole collection, 1895-1915.*

This is an extensive collection of original glass negatives of images by the Poole Photographic Studio. The family firm of A.H. Poole operated as commercial photographers in Waterford, with most of the work being commissioned by clients. The Poole Photographic Studio recorded people and events in the area including Waterford city, New Ross, Tramore and southern areas of Co. Kilkenny. The firm's first premises were at Rose Lane (as The Waterford Photographic Company), then at 134 The Quay (as Poole's Stores), almost next door to Reginald's Tower, a Waterford landmark. Later, the business moved to 34 The Mall.

Even before the time the firm opened, the industrial revolution had a significant impact on the port city of Waterford: shipping increased and hotels multiplied, and so the population and variety of activities in Waterford grew accordingly. Railways made nearby tourist spots like Tramore more accessible. As life in Waterford burgeoned, up through the 1950s, the firm recorded events and people connected with shipping and shipbuilding, community activities, foxhunting and horse breeding, and tourism. The Poole Photographic Studio was in business until 1954.

While portraits of Waterford people dominate this collection, the topical photographs reveal more of Waterford's daily life and development. These depict such subjects as: turkeys being brought to market, The Quay; the Granville Hotel, Meagher's Quay; a three-masted barque at Grattan's Quay; Fife and Drum Band, 1900; Coal at docks, Mr. Murphy's, Ferrybank, 6 November 1901.

The negatives in this collection are of four sizes, and the majority of the images are portraits. A group of 2,000 whole-plates (1884-1954) depicts notable people, places and events rather than exclusively local portraits, and is significant in having warranted the larger (hence more expensive) image. The bulk of the collection is studio portraits of local individuals, and to a lesser degree of group photographs of business employees, religious schools, clubs, and societies. Some postcard views are included such as images of local businesses.

Supplementary to the negatives, the material also includes over 120 account books ("daybooks") and order books and three indexes, providing the name of the client who commissioned the work, the date, and sometimes notes on the subjects.

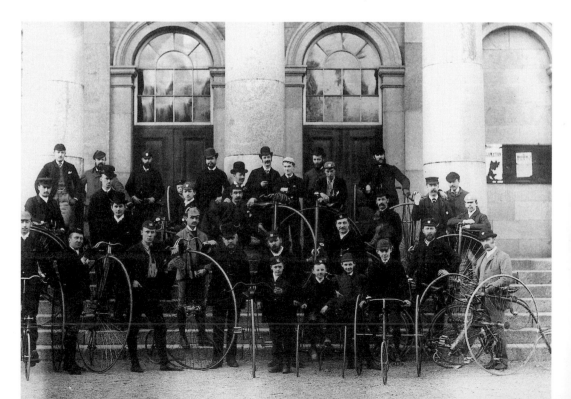

Dorothy Stopford Price (1890-1954), a Dublin pediatrician who specialised in the prevention and treatment of tuberculosis, was a niece of historian Alice Stopford Green. Her support of Irish independence in the mid-1910s gave way in 1921 to work to improve children's health. Dorothy Stopford married Liam Price in 1925.

This small personal collection contains studio portraits of Dorothy Price; snapshots of her with friends; Ina Roos; the residents and house surgeons at Meath Hospital, 1919, where Price worked with Professor William Boxwell.

■ **Dorothy Stopford Price Photograph Collection**

1910-1925
11 photographic prints, and 9 film negatives

ACCESS:
By personal application.

RELATED COLLECTION:
Alice Stopford Green Photograph Collection.

PROVENANCE:
From the papers of Dorothy Stopford Price; donated by Robert J. Stopford; 1975; acc. 3212.

Dr. Michael Quane (*d. ca.* 1970), administrator in the Department of Education with a special interest in charitable and endowed schools, included this varied array of career-related photographs with his papers. The images include: copy prints, *ca.* 1961, of portraits from the National Portrait Gallery, London; a studio portrait probably of Dr. Quane; buildings, possibly schools; photographs of architectural drawings by Eileen Johnston of school buildings; the Ordnance House in Ennis; a copy of an 1839 academic degree from Ennis College.

■ **Dr. Michael Quane Photograph Collection**

1920-1965
48 photographic prints

ACCESS:
PC97 Lot41.

PROVENANCE:
From the papers of Dr. Michael Quane; 1974; MS acc. 3046.

Left: Members of Bicycle Club with an array of penny farthing bicycles and tricycles outside Waterford Court House, *ca.* 1902. (Poole Collection. Poole Imp. 157A)

■ Helen Hooker O'Malley Roelofs
Photograph Collection

1974-1995
434 photographic prints, plus
corresponding film negatives

ACCESS:
Surrogate copies are available for
reference, with indexes.

RESTRICTIONS:
Copyright by the Helen O'Malley
Trust.

RELATED EXHIBITION:
An exhibit of a selection of the
photographs was held at the Royal
Hospital, Kilmainham, June-
November 1992.

PROVENANCE:
Gift of Helen O'Malley Roelofs;
1992.

Helen Hooker O'Malley Roelofs (1905-1993) was an American photographer and sculptor. She studied in France, Moscow, and Greece. In 1935 she married Ernie O'Malley and moved to Ireland, living in Dublin and Co. Mayo. In 1945 she founded the Players Theatre in Dublin. In the 1950s she returned to the United States, and married Richard Roelofs, Jr. Thereafter she spent time in Ireland doing sculpture, writing, and photography. Her sculpture and photography have been exhibited internationally beginning in 1945.

This collection comprises mainly views, architectural details of ancient monastic sites in Ireland, and informal portrait photographs. Most subjects are topographical, with an emphasis on texture and human interest. Subjects include: Jerpoint Abbey, Co. Kilkenny; Glendalough and Mount Usher, Co. Wicklow; castle at Kilteel, Co. Kildare; landscapes in the west of Ireland; Irish people (45 images including Paddy Moloney and Seán Potts of The Chieftains, and writer Mary Lavin); Irish museums and churches, 1978; Burrishoole Lodge in Newport, Co. Mayo; and scenes in Dublin, especially Lansdowne Road, St. Stephen's Green, and the Grand Canal. Most images are black-and-white 8" x 10" prints.

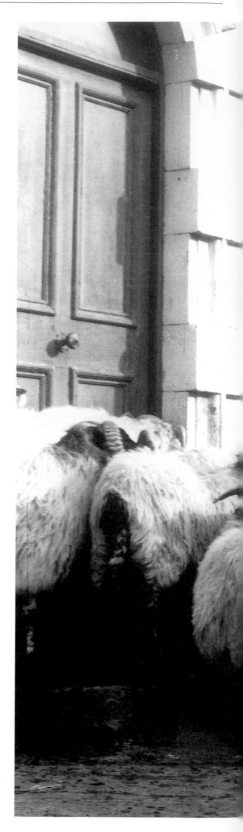

Sheep in the marketplace, Co.Mayo, 1974.
(Roelofs Collection. R. 28,705)

■ **Royal Archives, Windsor Castle, Photograph Collection**

1860-1880
77 photographic prints (copy prints)

ACCESS:
PC98 Lot3.

RESTRICTIONS:
Copyright Windsor Castle.

PROVENANCE:
Purchased from the Royal Archives, Windsor Castle; 1987.

These are mid-19th century photographic views of Dublin and Killarney, and scenes at the Curragh Camp ("Souvenirs of Soldiering at the Camp Curragh, 1861"). Among these modern black-and-white copy prints are early images of Dublin's Custom House with masts of sailing ships in the foreground; the Four Courts; Grafton Street; the Bank of Ireland and Trinity College; entrance to the Royal Hospital at Kilmainham; and Westmoreland Street. Some images are framed by hand-drawn decorative devices; they may be from a hand-made album.

■ **Vincent Scully Photograph Collection**

1885-1925
15 photographic prints

ACCESS:
By personal application. Card catalogues provide indexing.

PROVENANCE:
Gift of Betty and Maurice O'Connell; 1996.

Vincent James Scully (1846-1927) was the son of Vincent James Scully (1810-1871), Q.C., M.P. (Cork). This small family collection includes photographs of the younger Scully's family members at their house Mantle Hill, Golden, Co. Tipperary, and at Meadow Hill, Tunbridge Wells, Kent. Depicted are:

Vincent James Scully, his wife Emma Barron Scully; their children Catherine (Kate), Manuella, Louise, Vincent, Jr. and Denys (1873-1919); Mr. Fahy the footman at Loughlinstown House with a donkey and cart; Emma Scully's sisters Kate Barron and Mary O'Keefe, and her brother Canon Eustace Barron.

A portrait of the Vincent Scully family of Mantlehill, Co. Tipperary, *ca.* 1892. (Scully Collection. Trans. 114)

Hanna Sheehy Skeffington (1877-1946), suffragette, socialist, republican, and journalist, was the daughter of an M.P., and niece of Land League activist Fr. Eugene Sheehy. A brilliant student in the Royal University of Ireland class of 1902, she taught in Dublin, and in 1903 married Francis Skeffington, university registrar and later a pacifist and journalist. The two collaborated on feminist and socialist projects, including founding the Irish Women's Franchise League and the influential paper Irish Citizen. They were active during the extended 1913 labour lock-out, Hanna being jailed while distributing women's suffrage pamphlets.

After her husband was killed following the 1916 Rising, Hanna toured the United States speaking on behalf of the nationalist cause. With other republican suffragettes, she rejected the Anglo-Irish Treaty of 1921, but worked to stop the Civil War. She continued to be an active feminist and journalist, and was jailed several times. In 1943 she contested in the general election, demanding equality for women, but was defeated.

The collection contains studio and informal portraits of a wide-ranging group of Sheehy Skeffington's friends, family, and colleagues, including many political personalities, as well as unidentified people. There are also news cuttings, portrait prints, drawings, and associated items. Portrait subjects include: Hanna Sheehy Skeffington, Francis Sheehy Skeffington, graduates of the Royal University (including Hanna Sheehy Skeffington), the Rev. Eugene Sheehy, Declan Hurton, Mary Clandillon, Countess Markievicz as Joan of Arc, Éamon de Valera, James Larkin, Molly and Freda Baker, Susan B. Anthony, Harry Boland, Linda Kearns, Violet Vanbrugh and Arthur Bourchière, Sean O'Duffy and Kathleen Boland, Rory O'Connor, Elizabeth Freeman, and Alice Park. The collection also includes stills from the 1931 Hollywood film "Cimarron" starring Richard Dix and Irene Dunne; scenes from the ca. 1920s play by Jerome K. Jerome, "The Passing of the Third Floor Back." It also includes images of women's suffrage events, such as a U.S. National Women's Party event, and a 1924 parade in San Pedro, California; an original suffrage cartoon drawing by "F.M."; caricatures from Punch; a souvenir booklet from the 1907 Dublin Exhibition; and portraits of many unidentified women, possibly feminist colleagues.

■ Hanna Sheehy Skeffington Photograph Collection

1885-1956; bulk, 1910-1940
ca. **400 photographic prints, plus printed items and pamphlets**

ACCESS:
PC97 Lot29(1-4). Reference photocopies of many images are available. A subject listing of these images is also available. These materials are also indexed in the card catalogue. Other materials accessible by personal application.

RESTRICTIONS:
Donor permission is required to reproduce material.

PROVENANCE:
From the papers of Hanna Sheehy Skeffington; from Ms. Andrée Sheehy Skeffington; 1981; MSS acc. 3847, 3859, 3896.

Poole Studio portrait of the suffragette Hanna Sheehy Skeffington. (Poole Collection. R.26,517)

■ **James DeLacy Smyth
Photograph Collection**

**1865-1920; bulk, 1880-1900
15 items : 9 photographic prints
and 6 photolithographic
postcards**

ACCESS:
By personal application.

PROVENANCE:
From the papers of P.J. Smyth.

James DeLacy Smyth was the son of P.J. Smyth, M.P. The elder Smyth was a Young Irelander and nationalist M.P., as well as friend of Thomas Francis Meagher and others. Accordingly, items in this group are mostly portrait photographs of Irish political personalities (1865-1916), including Young Irelanders; also, a carte-de-visite of Thomas Francis Meagher in uniform, presumably during the American Civil War, based on a photograph by Mathew Brady of New York; portraits of Denis Florence McCarthy, William Smith O'Brien, John Mitchel, and P.J. Smyth; photographs of paintings of William Smith O'Brien and Tim Devin Reilly; 1916-vintage lithographic postcards of Patrick O'Donoghue, Con Colbert, Edward Daly, Alfred O'Rahilly (The O'Rahilly), Cardinal Newman, and Archbishop Walsh.

Young Irelander P.J. (Patrick James) Smyth, *ca.* 1880. (DeLacy Smith Collection Trans. 115)

The Spillane family owned a bar in Castletownbere, Co. Cork, in the early 1900s. The photographer member of the family was a journalist for the *Irish Independent*. This collection depicts people and events in Castletownbere. Subjects are: the old Roman Catholic church, 1900; Castletownbere main street,

ca. 1900; fair day at the west end of Castletownbere's main street, 1906; scenes from 1913 including a military funeral, pollack fishing, Dunboy Castle from the sea, an old fisherman, outside Spillane's Bar with Misses Teresa and Julia Spillane and a customer, the Kilmakillogue pattern (religious festival), July 1913.

■ **Spillane Photograph Collection**

1890-1913
26 glass negatives

ACCESS:
Accessible to staff only.

PROVENANCE:
Acquired from Mr. Terry Spillane;
ca. 1988.

Spillane's bar in Castletownbere, Co. Cork, *ca.* 1913. (Spillane Collection. Spillane 26)

■ Stereo Pairs Photograph Collection

1860-1883
3,059 glass negatives (3¼" x 6¾")

ACCESS:
A bound reference aid provides a listing of images by county; it is entitled "Shelf-List of Stereo-Pair Negatives in the National Library of Ireland" (1981). Some images are reproduced in the National Library's 1981 publication, cited below. Negatives are accessible to staff only.

RELATED PUBLICATION:
Ireland 1860-80 from Stereo Photographs. *(National Library of Ireland Historical Documents) Dublin: National Library of Ireland, 1981.*

PROVENANCE:
Purchased as part of the Lawrence Collection; 1943.

While this collection was acquired with the Lawrence Collection, historically it has been treated as a separate collection, as it covers an earlier time, is in a different format, and was not created by the Lawrence firm.

This collection of stereographic negatives documents life in Ireland during a period of relative prosperity and peace. Scenes are primarily picturesque views, postdating the Famine years and bypassing the disruption of the Land Wars. Most but not all images are identified as to county and town. Twenty-six counties are represented, including Antrim, Armagh, Clare, Dublin, Donegal, Limerick, Offaly, Tyrone, and others.

Beginning in the mid-19th century, stereographic photographs were made with a special camera with two lenses side-by-side, simultaneously taking two nearly-identical images. When the mounted print is viewed through a special viewer (stereoscope), a three-dimensional effect is created. Stereos became popular when Queen Victoria showed enthusiasm for the novelty at the Great Exhibition of 1851. Among Dublin photographers who provided images for stereo views was James Simonton, with a business in Grafton Street (Royal Panopticon of Science and Art) and Frederick Holland Mares, who generated a collection of Irish views.

Some of these photographers' negatives were acquired by John Fortune Lawrence, a Grafton Street merchant who owned a photographic gallery. His brother William Mervyn Lawrence eventually marketed these and other stereographs. The popularity of stereos waned around 1880, but they were made up until the 1920s. Lawrence probably did not print stereos after the mid-1880s.

The Glendalough Hotel, with the round tower prior to its restoration in the background. (Stereopairs Collection. Sp. 887)

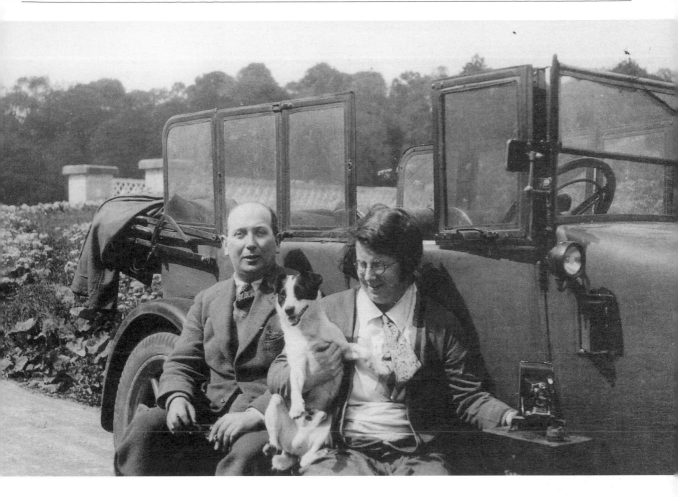

Born in South Africa, Dorothy Stokes (1898-1982) was the daughter of a doctor from Dublin. She became a professor in the Royal Irish Academy of Music in Dublin. In her spare time she was an energetic traveller and keen amateur photographer. Her snapshots and photograph albums include hundreds of views of Ireland and places abroad, also informal group portraits of herself and her many friends.

This extensive collection comprises mainly personal photograph albums.

There are also loose snapshots and some corresponding negatives. For each album, Ms. Stokes carefully arranged the images on each page, captioned each photograph, and, in the later albums, added commercially-produced postcards, labels, and other colourful graphic ephemera for visual interest and information. Some of the albums are: Ireland 1927; Achill Island 1933; Scotland and Liverpool 1939; Norway 1950; Ireland 1951; Mediterranean cruise 1956; Europe 1962.

■ **Dorothy Stokes Photograph Collection**

1920-1965
29 albums : ca. 800 photographic prints, plus over 100 loose prints and negatives

ACCESS:
Albums 214-243. Access to loose photographs is by personal application only.

PROVENANCE:
From the papers of Dorothy Stokes; gift of Hickey, Beauchamp, Kirwan, O'Reilly, solicitors; 1983; acc. 4012A.

Dorothy Stokes travelled widely while not teaching music at the Royal Irish Academy of Music. Seen here with camera and friends, *ca.* 1932. (Dorothy Stokes Photograph Collection. R. 28,878)

■ **Tempest Photograph Collection**

1904-1910
91 glass negatives

ACCESS:
By personal application.

PROVENANCE:
Gift of Mr. C. Tempest McCrea,
nephew of Harry Tempest; ca. 1992.

William Tempest (1837-1918) of
Dundalk, Co. Louth, founded and
operated a successful publishing,
printing and stationery business there
from 1859 and continuing through the
1970s as Dundalgan Press (W. Tempest),
Ltd. The company published *The
Tempest Annual,* an annual directory and
almanac for Dundalk, Drogheda,
Newry, Ardee, and environs.

In keeping with William Tempest's
vocation of documentating and
informing his son Harry Tempest, a
writer and local historian, took these
informative and appealing images. The
photographs show life in Dundalk,
Ardee, and the surrounding area in the
first decade of the 20th century.
Subjects include: Election day, 1906; a
family tea party outdoors; shops,
including Tempest's; the ladies' golf
links; St. Patrick's Day, 1905; picnics; the
Ardee Fair; general views of Ardee; and
members of the Tempest family.

Interior of Tempest's stationery and printing
shop, *ca.*1905. (Tempest Collection. Tempest
No. 68)

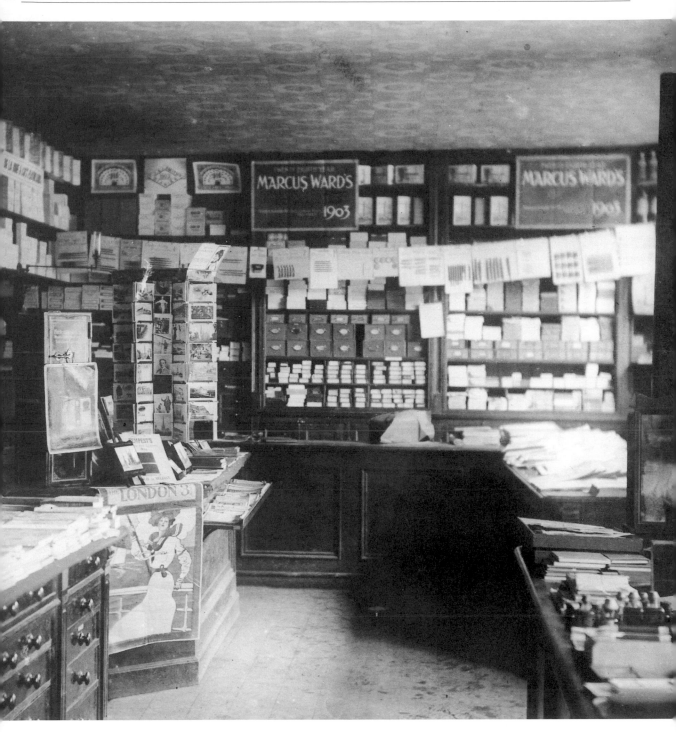

Alfred R.W. Ternan was an architect in Dublin, active in the 1930s through the '50s. This collection of slides from the mid-1900s onwards documents Dublin, other Irish locales, and parts of Europe. The glass negatives are portraits, said by the donor to have been taken by James Jackson, a great-grandfather of the donor and a paymaster in the Royal Navy. These may have been taken as early as 1880. The prints are *ca.* 1920; some depict the Dublin Officers' Training Corps guard being inspected by Maj. Sir R. Tate, 17 March 1920, and the posting of the first sentries from Trinity College on Lower Castle Yard gate on the same day.

■ **Alfred R. W. Ternan Photograph Collection**

1880-1960; bulk, 1930-1960
***ca.* 500 colour film slides, plus 8 glass negatives and numerous photographic prints and 3 albums**

ACCESS:
Albums 150,151 and 162. Other material available by personal application.

RESTRICTIONS:
Reproduction may be restricted; consult staff.

PROVENANCE:
Gift of the son of Alfred R.W. Ternan; ca. 1986.

Dublin University Officers' Training College guard being inspected by Maj. Sir R. Tate before starting for lower castle yard, 17 March 1920—A.R.W. Ternan is third from right, back row. (Ternan Collection. Trans. 118)

■ Dorothy Harrison Therman
Photograph Collection

1981-1991
144 photographic prints, plus
104 colour film slides and
negatives

ACCESS:
PC97 Lot25.

RESTRICTIONS:
*Reproduction may be restricted;
consult staff.*

RELATED PUBLICATION:
*Dorothy Harrison Therman.
Stories from Tory Island. Dublin:
Country House, 1989. This work
combines oral histories from Tory
Islanders with colour photographs
found in this collection.*

PROVENANCE:
*Gift of Mrs. Dorothy Harrison
Therman; 1993.*

Dorothy Harrison Therman, an
American from Pennsylvania born in
1917, visited Tory Island, nine miles off
the northwest coast of Co. Donegal,
most summers between 1981 and 1991,
before the regular ferry connection with
the mainland. She recorded stories and
oral histories of inhabitants, and
photographed people, structures, and
scenes of life on Tory. This collection
consists of her colour photographs of
people and places on Tory Island where
the unique island culture is rapidly
giving way to influences from the
mainland. Among the images are
landscapes, seascapes, East and West

villages, views from a helicopter, informal portraits especially of the Rogers and Doohan families, fishing boats and fishermen, distinctive doors and windows, and children dressed for their first communion. Images are good quality and show in colourful detail the everyday life on the island.

Fishermen on Tory Island in the 1980s. (Therman Coll. Therman neg. 14)

■ **Col. F. Thornton Photograph Collection**

1929-1933
ca. **241 photographic prints**

ACCESS:
By personal application.

PROVENANCE:
From the papers of Col. F. Thornton; 1978; MS acc. 3536.

Col. F. Thornton served in the British Army in France during the First World War, and was in Russia in 1919. From brief entries in his diaries, 1917-1935, he travelled widely thereafter, spending time in Bombay in 1924, Cairo in 1928 and 1930, and also was active in hunting and shooting in England, and London social life, during that period. Thornton appears to have been a keen amateur photographer, but other details of his life are imprecise. These materials were found in a rubbish skip and donated to the Library in 1978.

This collection comprises personal photographs of good quality including artistically composed holiday views, landscapes, people, dogs and horses. It includes images from 2" x 3" to 5" x 7", some with brief captions: Sphinx; Austria 1927; Mena Camp 1930; old Turkish prison, Skopje; arrival of Spondigni; Rye Church, East End; Cows at Bisham ("slightly overexposed"). Many prints include technical details including f-stop, printing and cropping notes, attesting to Thornton's enthusiasm.

Col. F. Thornton a keen hill walker, travelled with camera on these trips as can be seen from the detail in this shot in the Alps in the 1930s. (Thornton Collection. R. 28,198)

Pádraig Tyers lived in Cork and taught in a secondary school there. He worked at University College Cork from 1965 to 1988. These images are modern copy prints of original photographs collected by Tyers, beginning in 1948. The images, most uncredited, show social and cultural life on the Dingle Peninsula and elsewhere, in Co. Kerry, focusing especially on people. Some subjects are: crossroads dancing, *ca.* 1900; Blasket islands author Tomás Ó Criomhthain, *ca.* 1910; a Beamish stout lorry being used as a bus, 1939-1945 (the Emergency). The quality of images varies. Tyers' photographic history of Cork noted at right incorporates most of these images.

■ **Pádraig Tyers Photograph Collection**

1888-1960
ca. **110 photographic prints (copy prints, 4" x 5"), with corresponding copy negatives**

ACCESS:
PC97 Lot23. Surrogates are available as a reference aid.

RELATED PUBLICATION:
Tyers, Pádraig. Ceamara Chorca Dhuibhne: Cnuasach Griangraf 1888-1960. Dún Chaoin: Inné Teoranta, 1991. Images are arranged in sections including the following: People, The sea, The young, Traveling, Dingle, War, The Blaskets.

PROVENANCE:
Purchased; copied from material on loan from Pádraig Tyers; 1991.

A Beamish lorry being used as bus during the Emergency, 1939-1945. (Tyers Collection. R. 24,903)

■ **Ulster Museum Photograph Collection**

printed *ca.* 1995
144 photographic prints (copy prints, 4" x 5")

ACCESS:
By personal application.

RESTRICTIONS:
Copyright by the Ulster Museum.

PROVENANCE:
Purchased; 1995.

This collection consists of black-and-white copy photographs of 18th-, 19th-, and 20th-century portraits of distinguished Irish men and women. Original works depicted include oil paintings, engravings, death masks, busts, drawings and photographs. The 144 people depicted include prominent artists, writers, businessmen, philanthropists, political figures, for example: Douglas Hyde (1860-1949); John Jameson (1740-1823); James Joyce (1882-1941); Richard Kirwan (1733-1812); Sir Hugh Lane (1875-1915); Mary Catherine MacAuley (1787-1841); John Mitchel (1815-1875); Louis MacNeice (1907-1963); Nathaniel Hone (1718-1784); Edith Somerville (1858-1949).

■ **Valentine Collection**

1903-1960
ca. 3,000 negatives : glass negatives and film negatives

ACCESS:
A reference aid provides surrogates of 36 postcards of the "Sinn Fein Rebellion" (i.e., 1916 Rising). A comprehensive finding aid provides alphabetical access by county and place to the topographical material. In this same finding aid is an item list for the three additional groups. The "Valentine Collection Shelf List" lists all Valentine glass negatives, in numerical order. No surrogates for these images are available.

RELATED PUBLICATION:
Smart, Robert. "James Valentine 1859-1879," in Mood of the Moment: Masterworks of Photography from the University of St. Andrews. *Ed., Martin Kemp. 1996.*

PROVENANCE:
Acquired from Duffner Brothers; ca. 1980.

In 1851, enterprising engraver-stationer James Valentine added portrait photography to his business in Dundee, Scotland; topographical views he added about 1860. His son William Dobson Valentine (1844-1907) expanded the business. In 1898, when a new postal regulation enabled the use of postcards, 'photographic publishers' Valentine & Sons began generating images for the postcard trade.

Valentine's period of greatest photographic postcard activity was between 1929 and the 1950s. Staff photographers took most of the photographs; a few were purchased or commissioned from other photographers, including Duffner Brothers of Dundalk. Many of the film negatives are copies cut to postcard size. Sometimes the postcards were contact-printed onto a roll of paper moving forward in postcard-sized steps, resulting in a fast and cheap production process.

This is a collection of commercial postcard negatives from Valentine and Sons. The views are confined to the Republic of Ireland. Typical views include: towns, villages, and urban scenes; streets, bridges, automobiles; and shops and residential structures. The collection includes such varied views as those by the Grand Canal, scenes of the 1916 Rising in Dublin, harvesting turf in Co. Louth in the late 1940s, and a Gaelic football match in the 1950s. Three small groups are also included—"Irish Life," "Irish Studies," and "Film stars". "Irish Life" images depict genre subjects such as "Fair Day" or "Cottage." "Irish Studies" is reproductions of paintings, with verse by Eva Brennan. The "Film stars" group includes mostly British and American actors, such as Anne Baxter, Alice Faye, Margaret Lockwood, Walter Pidgeon, and Harold Warrender.

Above:
St. Kevin's Cross and Kitchen, Glendalough showing a guide explaining to visitor how to receive good luck. (Valentine Collection. J.V. 84198)

Below:
Feeding time for the elephants at Dublin Zoo, *ca.*1940s. (Valentine Collection V.R.548)

■ **Various Photograph Albums**

1860-1960
ca. **110 albums**

ACCESS:
A reference aid has been compiled detailing indiviual albums. The albums are available for perusal by personal application.

PROVENANCE:
Various sources.

This group of approximately 110 photograph albums are not otherwise described in this guide. The collections contain over 300 albums, as of 1997. A few have been given individual entries elsewhere in this guide. Some, such as the Hillery, Haffield, and Stokes albums, have been described with those collections. The remaining 110 albums, while acquired from many different sources, are best described collectively. Further investigation will provide researchers with additional details. The albums fall into four general categories, described below.

The largest category is the *family and travel album.* There are approximately 45 in this grouping. These comprise family snapshots and other amateur photographs. The popularity of amateur photography starting in the 1890s meant that these albums were numerous but also that the images contained in them were a select group. Their subjects—chiefly locales and people—are often unidentified. Identified locales include Ireland, Switzerland, Austria, England, Italy, Greece, Germany, Belgium, and France. Several albums contain images of South Africa during the Boer War, and of the Cameroons during the First World War. The quality of these images varies.

A second category is the *carte-de-visite* album. There are approximately 20 albums in this grouping. These albums contain the small (4" x 2½") commercially-produced card-mounted portrait photographs, called *cartes-de-visite.* Beginning around 1859, cartes could be bought quite cheaply (12/6 per dozen at the time) by people wishing to use them like calling cards. A collecting craze reached its height in the mid 1860s; the cards were made until 1900. Enterprising photographers sold cartes of notable people, such as Queen Victoria and William Smith O'Brien, to collectors. The albums themselves, about 4" x 6", were commercially produced with elaborate covers and

metal clasps, and held slotted pages for inserting the cartes. Similar but larger albums also included a few pages for the similar but larger cabinet card, 6½" x 4½". In the National Library's collections, portraits are primarily of royalty and other notables, as well as many unidentified persons. Some sitters are identified, usually in captions written on the album pages. The collections contain albums of the following families: De Cobain, Grove-White, Evans, Bradley, Fortescue, Belloc, Osborne and Dixon, and Cusack-Smith, as well as others unidentified. Many of the cartes-de-visite in the Library's albums are by Dublin photographers, including Mares, Lesage, Glover, Sauvy, and many others.

A third category is the *personal topographic views* album, of which there are approximately 15. These are personal albums made up of purchased commercial photographic prints and postcards of general landscape views, estates and archaeology in Ireland. Most of the prints are from the firm of William Lawrence. Some of the albums were assembled with care and artistry, as such recreation was the fashion in the mid- to late 19th century.

A fourth category is the *published album,* of which the collections contain over 20. These are mostly William Lawrence Co. publications, produced for the tourist trade between 1890 and 1920. These view books contain colour photolithographs of Lawrence photographs and descriptive text. They depict locales including Dublin, Belfast, Wicklow, and Cork and Queenstown (Cobh). Several were printed in Germany, where Lawrence had business contacts.

In addition, there are a number of albums that fall outside the scope of the above four categories. These vary widely from published albums to newscuttings albums, to house inventory photographs. There are about 10 of these miscellaneous albums.

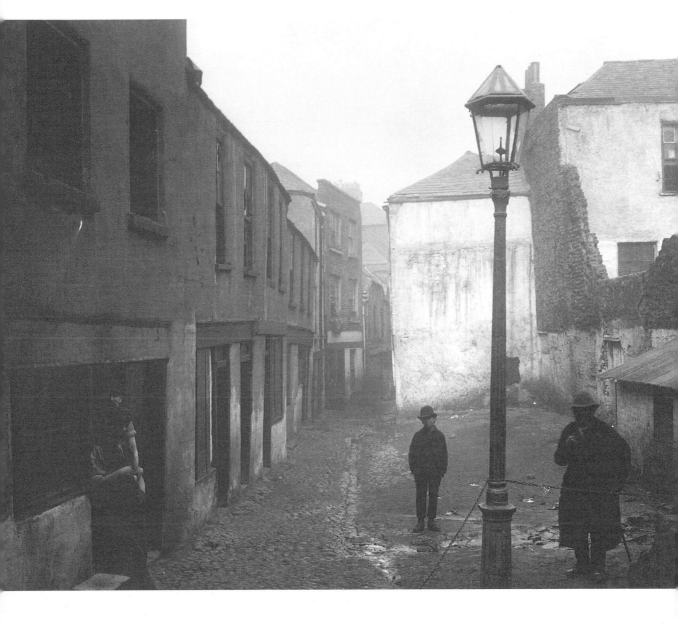

Upper Meeting House Lane from Wormwood Gate, 20th October 1888. This is one of a number of atmospheric images of this part of Dublin, in the John's Lane and Mullinahack Album. (Photograph Album 7. Trans. 178)

■ **Various Negative and Lantern Slide Collections**

1890-1950
ca. **12 collections of glass negatives and lantern slides**

ACCESS:
Accessible to staff only.

PROVENANCE:
Various sources.

In addition to those negatives and lantern slides described in separate entries in this guide are other small collections of negatives the scope and significance of which has yet to be determined. These include the Bools Negative Collection; Crawford Negative Collection; Geoghegan Negative Collection of paintings in the National Gallery, *ca.* 1910; Heazle Negative Collection; Joan Hollingsworth Negative Collection of farming scenes, 1930-1950; Kylemore Negative Collection of images of Kylemore Abbey and environs, Co. Galway, 1900-1920; Jim Larkin Negative Collection of Belfast, 1907 labour dispute; Rathangan House Negative Collection (MS. acc. 3236); Scraps Negative Collection, scrap album images for collectors' albums; and several others.

The interior of Kylemore Abbey's gothic chapel, which is among 112 glass plates of Kylemore Abbey and its environs. (Various Negative and Lantern Slide Collections. Kylemore 52)

The Waldron collection comprises copy prints, *ca.* 1990, of politically-oriented images, the most important of which is an election procession in Ennis, Co. Clare, June 1917, showing Éamon de Valera and Arthur Griffith. Images show men carrying "Vote for de Valera" banner. Also, Darrell Figgis addressing a Sinn Fein meeting in Limerick; an Irish Party meeting, 1912; Robert Byrne, whose death in 1919 sparked the Limerick Soviet; Gen. Liam Lynch lying in state, 1923; Éamon de Valera at Lourdes, *ca.* 1954, and with his wife possibly at Baldonnel Military airdrome in the 1950s. According to the donor, the photographs were taken by his father John Waldron (1884-1959) or his father's twin brother Patrick Waldron (1884-1953). Some images are quite faded.

■ **Patrick H. P. Waldron Collection**

1912-1960; bulk, 1917
15 photographic prints (copy prints)

ACCESS:
By personal application. Subject-indexed in card catalogue.

RESTRICTIONS:
Donor permission is required to reproduce images.

PROVENANCE:
Gift of Patrick Waldron, B.L.; 1991.

Kilcorney
Parish

Burren

May 3. 1898

Fallen cromlech & monument
Ballynihil

Feakle
Parish

upper Tulla

Sep 5. 1898

Tobergrania cromlech
now used as a holy well

Thomas Johnson Westropp was a notable antiquary who wrote extensively on the history of a number of counties. He also had a penchant for photographic documentation, a late-19th century pursuit in the tradition of earlier antiquarian topographical artists as George Petrie (1789-1866), George du Noyer (1817-1869) and William Frederick Wakeman (1822-1900), who documented Ireland's picturesque locales including ruined abbeys and castles in their watercolours and engravings.

Westropp's unique volumes contain an extensive set of images of antiquities in fourteen counties, principally Co. Clare. The volumes are entitled on the spine: "Irish Antiquities." Some images include people. Handwritten captions include date and location including parish, barony and town. The first volume was completed in 1898. Additional photographs were added to several of the volumes after the volumes were first

donated to the Library. Volumes 1, 6 and 7 include indexes to place and subject.

Vol. 1: Co. Clare; also Counties Mayo, Limerick, and Waterford.

Vol. 2: Co. Clare; also Counties Galway and Limerick.

Vol. 3: Counties Antrim, Clare, Cork, Down, Dublin, Galway, Kerry, Kildare, Limerick, Mayo, Waterford, Wexford, and the Aran Islands; 1902-1911.

Vol. 4: Counties Clare, Kerry, and Mayo.

Vol. 5: Counties Clare, Galway, Kerry, Limerick, Mayo, and Waterford.

Vol. 6: Counties Clare, Cork, Donegal, Limerick, Louth, and Mayo.

Vol. 7: Counties Clare, Galway, Limerick, Meath, Tipperary, and Wexford; 1918.

Vol. 8: Counties Cork, Dublin, Galway, Limerick, and Meath; 1916.

Vol. 9: Counties Cork, Dublin, Meath, Wexford, and Wicklow; 1902-1921.

■ **Thomas J. Westropp Antiquities Albums**

1898-1921
9 albums : *ca.* 1300 photographic prints (*ca.* 144 per album)

ACCESS:
Albums 261-269.

RELATED COLLECTIONS:
Thomas J. Westropp Easter Rising Album. Also, Westropp's The South: Isles of Arran, an album of sketches, 1878, in the Prints and Drawings Department.

PROVENANCE:
Gift of Thomas J. Westropp; 1898-1921.

The impressive detail which accompanied Westropp's photographs are shown opposite from Album 261, Volume I in his series of Irish Antiquities. (Westropp Antiquities Albums. Trans. 119)

■ Thomas J. Westropp Easter
Rising Album

May 1916
1 album : 32 photographic prints

ACCESS:
Album 196.

RELATED COLLECTION:
*Thomas J. Westropp Antiquities
Albums.*

PROVENANCE:
Gift of Thomas J. Westropp; 1925.

This album is entitled: "Photographs of
the Ruins of Dublin after the Sinn Fein
Rebellion, April 24, 1916, taken by
Thomas J. Westropp, May 17-18th,
1916." It provides a personal graphic
document by skilled amateur
photographer and antiquary Thomas
Johnson Westropp.

Most images are captioned by
Westropp. While some images are
similar to other photographs of the time,
others are unusual as they depict ruins
of lesser-known buildings and locales,
such as a laneway at Liberty Hall, and
women and children near ruined areas.

The General Post Office and Nelson's Pillar from Henry Street following the 1916
Rising. (Westropp Easter Rising Album 196. Trans. 120)

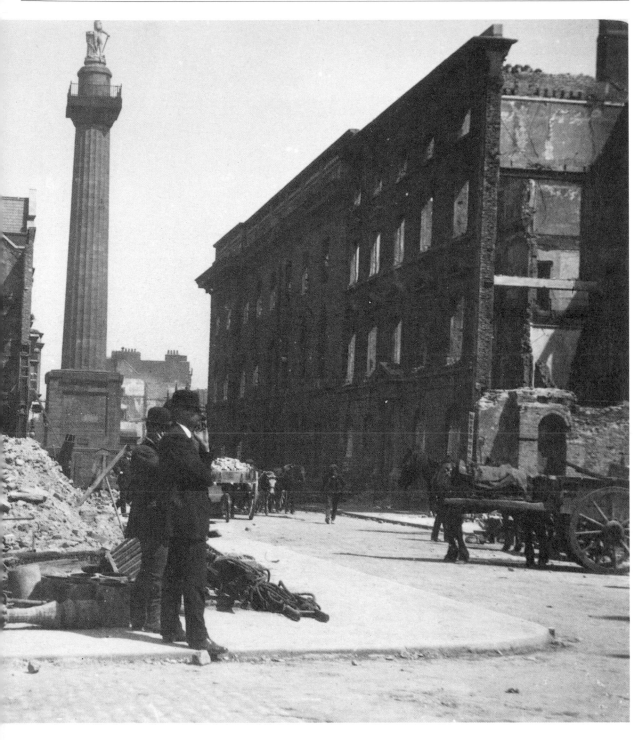

This rich collection comprises photographs by Elinor O'Brien Wiltshire and her husband Reginald Wiltshire, owners of The Green Studios, Ltd., Dublin (1958-1968, St. Stephen's Green; after 1968, Harcourt Street). The photographs were taken for the photographers' pleasure rather than commercial purposes. The black-and-white images document life in Ireland in the 1950s and '60s. Subjects include: travellers in Loughrea, Co. Galway, 1954; poet Patrick Kavanagh (1904-1967) in his hometown of Inniskeen, Co. Monaghan, 1963; Kavanagh at the Martello Tower in Sandycove on the 50th anniversary of Bloomsday, June 16, 1954, with filmmaker John Ryan,

Anthony Cronin, Brian O'Nolan (Flann O'Brien), and others; Kavanagh at a University College, Dublin, poetry lecture, 1958; barges on Dublin's Grand Canal, 1959; a large number of Dublin places and events, 1964-1969, such as bridges, children on Sandymount Strand, Moore Street markets, houses on St. Stephen's Green, the Five Lamps (signpost), gardai on O'Connell Street, Corpus Christi parade of 1969, derelict buildings on Mountjoy Square and the quays, York Street evictions 1964. Many of the buildings have since been torn down. Images are good quality and are considered to rank with the best of Robert French (photographer for William Lawrence) and Fr. Browne.

■ Elinor Wiltshire Photograph Collection

1951-1971
ca. **322 photographic prints (10" x 8")**
ca. **1000 film negatives**

ACCESS:
PC97 Lot33(1-2). A reference aid provides indexing to the images, with surrogates available for reference.

RESTRICTIONS:
No copyright restrictions; credit "Wiltshire Collection" for Patrick Kavanagh materials 1951-1967; "Elinor Wiltshire" for Dublin scenes and travellers images.

RELATED MATERIALS:
Audio and 16mm film material of Patrick Kavanagh from same source in National Library collections. These are to be credited: "Reginald Wiltshire."

PROVENANCE:
Purchased from Elinor Wiltshire, 1994.

A 1969 scene at Dublin's Cumberland Street shoe market. (Wiltshire Collection. Ref No.56-2)

■ **Wynne Photograph Collection**

1867-1960; bulk, 1880-1940
ca. **8,000 glass negatives**

ACCESS:
Accessible to staff only.

PROVENANCE:
*Gift of the Wynne family,
principally Mrs. Ita Wynne, widow
of a grandson of the founder; 1993.*

This is a sizeable collection of negatives for images created by the firm of Thomas J. Wynne (1838-1893), founder and proprietor of Wynne's Newsagents, and, from 1867, photographer to the community in and around Castlebar, Co. Mayo. Wynne made formal studio portraits of people in Co. Mayo, and images of eviction scenes and Land League meetings. He developed a flair for advertising and marketed his photographs successfully. His son took over the newsagent/photography business when he died, and this family business continues to thrive on Main Street in Castlebar.

The collection provides pictorial documents of life at all social levels in Co. Mayo, and is the Library's first major photographic collection from a Connaught town. Images include studio portraits of men, women and children, individually and in groups; portraits of such personalities as Maude Gonne McBride, Lord Lucan, Sean Lemass, and Captain Boycott; and unusual group portraits, including one of poítin distillers. Supplementary to the negatives are log books documenting photograph orders, 1989-1902, and 1938-1965.

A reception marking the acquisition of the collection was held at the National Library on 20 April 1993.

Children of Mrs. J. Jennings, Ballintubber. (Wynne Collection. Wynne 1462)

Rahins

Interior P. Church

Eviction Scenes

Photographs in this album were taken by Thomas J. Wynne, photographer and owner of the thriving newsagency and stationery shop in Castlebar, Co. Mayo (see previous entry). He commercially produced this album, and sold it for 30 shillings. Wynne's printed advertisement for the album is attached inside the front cover. Incorporated into the advert is the text of a laudatory letter from Co. Mayo emigrant Edmund F. Clyne of New York.

Images include rural and urban scenes, and some images of political meetings and community activities.

There is an image of photographer Thomas J. Wynne in his advertisement-filled shop window in Castlebar, 1871. Further are photographs of numerous churches, abbeys, ruins and street scenes, including Ballina, Westport, Tuam, Ballyvarey, and other towns; the holy well at Kilgeever with people nearby; Clew Bay; Murrisk Abbey; Father Lavelle of Cong; Ashford Castle and banquet halls; Lough Mask; Achill; Charlestown on market day; a marriage party; effigy of Judge Keogh in Castlebar; eviction scenes in Castlebar; the Castlebar railway station with train.

■ *Wynne's Souvenir Scrap Album of Mayo, Galway and the Western Highlands*

1873 or 1874
1 album : 140 photographic prints

ACCESS:
Album 33.

PROVENANCE:
Gift of the Wynne family; 1993.

Part of an album page showing two eviction scenes, *ca.* 1873, Co. Mayo. (Wynne Souvenir Scrap Album. Trans. 121)

GLOSSARY OF PHOTOGRAPHIC TERMS
USED IN THIS BOOK

CABINET CARD:

A card-mounted photograph, usually a portrait, 4" x 6". Similar to the smaller carte-de-visite. Introduced ca. 1866; overtook the carte-de-visite in popularity in the 1870s.

CALOTYPE:

The earliest negative (1841), on paper, made using a patented process developed by Englishman William Henry Fox Talbot. Superseded in the 1850s by the glass negative.

CARTE-DE-VISITE:

A small card-mounted photograph, usually a portrait, 2" x 4". Literally, French for "visiting card". Patented in France in 1854 and very popular among collectors through the mid-1860s. In use through 1900.

COPY NEGATIVE:

A negative made by taking a photograph of a pre-existing image, rather than from life. Not an original camera negative, so image quality not as high.

COPY PRINT:

A print made from a copy negative, copied from a pre-existing image. The image quality is slightly degraded from the original image.

DRY PLATE NEGATIVE:

The dominant negative type used between 1880 and 1920; more advanced than its predecessor, the wet plate negative. The photosensitive emulsion layer had been pre-applied and allowed to dry, so easier to use than the wet plate negative.

LANTERN SLIDE:

A positive image on glass, for viewing by projection; often made in sets for education or entertainment. Photographic lantern slides were made from ca. 1850 and used through 1920. Most commonly 3" x 4", with a cover glass and taped edges.

PANORAMA, PANORAMIC PHOTOGRAPH:

A photograph depicting a sweeping view; taken with a panoramic camera, or one having a wide angle lens; also, a combination of individual photographs arranged to give the same effect. Prints range from 10" wide up to 20 feet. Popular between 1900 and 1940.

PHOTOLITHOGRAPH:

Not a photograph, but a picture made from a lithographic printing plate (or plates in the case of colour) to which a photographic image has been transferred. Begun as an economical printing process in the mid-1850s.

PHOTOMECHANICAL PRINT:

Not a photograph, but a picture made from a photographically-prepared printing surface. Most have a distinctive dot or screen pattern. Includes halftone prints as found in newspapers.

STEREOGRAPH, STEREO VIEW, STEREO PAIR:

A double image appearing as three-dimensional when viewed through an apparatus called a stereoscope. Occasionally on glass but most often on a wide card mount, 3" x 7" or 4" x 7". Popular as home entertainment from 1850 through the 1920s.

WET PLATE NEGATIVE:

A negative requiring application of a wet photosensitive emulsion on a glass plate; the photograph must be taken while the emulsion is wet. This negative type was used from ca. 1855 until it was replaced in the 1880s by the dry plate negative. Distinguishable by creamy rather than grey tones, and by the presence of flow lines from the emulsion being hand-applied.

BIBLIOGRAPHY

Bence-Jones, Mark. *A Guide to Irish Country Houses.* Rev. ed. London: Constable, 1988.

Bence-Jones, Mark. *Twilight of the Ascendancy.* London: Constable, 1987.

Boylan, Henry. *A Dictionary of Irish Biography.* 2nd ed. Dublin: Gill and Macmillan, Ltd., 1988.

Coe, Brian, and Mark Haworth-Booth. *A Guide to Early Photographic Processes.* London: Victoria and Albert Museum, 1983.

Census of Ireland: General Alphabetical Index to the Townlands and Towns, Parishes, and Baronies of Ireland.... Dublin: Alexander Thom, 1861; Baltimore, Md.: Genealogical Publishing, 1995.

Chandler, Edward C. *Through the Brass-Lidded Eye: Ireland and the Irish 1839-1859, the Earliest Images.* Exhibit catalogue. Dublin: Guinness Hopstore, Autumn/Winter 1989.

Chandler, Edward C. *Photography in Dublin during the Victorian Era.* [Dublin]: Albertine Kennedy Publishing, 1982.

Cosgrave, E. Macdowel. *Dublin and Co. Dublin In the Twentieth Century.* Contemporary Biographies, edited by W.T. Pike. (Pike's New Century series, no. 26) Brighton: W.T. Pike & Co., 1908.

Dalsimer, Adele M., ed. *Visualizing Ireland: National Identity and the Pictorial Tradition.* Boston: Faber and Faber, 1993.

Dangerfield, George. *The Damnable Question: One Hundred and Twenty Years of Anglo-Irish Conflict.* Boston: Little, Brown and Company, 1976.

Edgeworth, Kenneth. *Jack of All Trades: The Story of My Life.* Dublin: Allen Figgis, 1965.

Evans, E. Estyn. *Irish Folk Ways.* London: Routledge & Kegan Paul, 1957.

Fay, Gerard. *The Abbey Theatre: Cradle of Genius.* Dublin: Clonmore & Reynolds, Ltd. 1958.

Foster, R. F. *Modern Ireland, 1600-1972.* New York: Penguin Books, 1989.

Hickey, D. J. and J. E. Doherty. *A Dictonary of Irish History Since 1800.* Totowa, N.J.: Gill and MacMillan, 1980.

Hickey, Kieran. *The Light of Other Days: Irish Life at the Turn of the Century in the Photographs of Robert French.* London: Allen Lane, 1973.

Hill, Myrtle, and Vivienne Pollock. *Image and Experience: Photographs of Irishwomen c. 1880-1920.* Belfast: Blackstaff Press, 1993.

International Federation of Library Associations and Institutions (IFLA) Core Programme on Preservation and Conservation. *Care, Handling, and Storage of Photographs.* Washington, D.C.: Library of Congress, 1992.

Jessop, Norma R., and Christine J. Nudds, eds. *Guide to Collections in Dublin Libraries: Printed Books to 1850 and Special Collections.* Dublin: Reprint Limited, 1982.

Kissane, Noel, comp. and ed. *Ex Camera 1860-1960: Photographs from the Collections of the National Library of Ireland.* Dublin: National Library of Ireland, with assistance from Kodak Ireland Limited, 1990.

Kissane, Noel, ed. *Treasures from the National Library of Ireland.* [Dublin]: Boyne Valley Honey Company, 1994.

Lee, J. J. *Ireland 1912-1985: Politics and Society.* Cambridge: Cambridge University Press, 1989.

Lester, DeeGee, comp. *Irish Research: A Guide to Collections in North America, Ireland, and Great Britain.* (Bibliographies and Indexes in World History, no. 9.) New York: Greenwood Press, 1987.

Long, Gerald. *The Foundation of the National Library of Ireland, 1836-1877.* A Dissertation submitted to the Department of Library and Information Studies as course work for the library history component of the Master of Library and Information Studies course. Dublin: University College, Dublin, May 1988.

Mollan, Charles, William Davis and Brendan Finucane, eds. *More People and Places in Irish Science and Technology.* Dublin: Royal Irish Academy, 1990.

Mollan, Charles, William Davis and Brendan Finucane, eds. *Some People and Places in Irish Science and Technology.* Dublin: Royal Irish Academy, 1985.

National Library of Ireland. *Report of the Council of Trustees of the National Library of Ireland.* Dublin: The Stationery Office [and others], 1877-1984.

Ní Dhuibhne, Eilís. "Photographs." In: *Treasures from the National Library of Ireland,* edited by Noel Kissane, pp. 107-129. [Dublin]: Boyne Valley Honey Co., 1994.

Nowlan, Kevin B., ed. *Travel and Transport in Ireland.* Dublin: Gill & Macmillan, 1973.

O'Ceirin, Kit and Cyril O'Ceirin. *Women of Ireland: A Biographic Dictionary.* Newtownlynch: Tir Eolas, 1996.

O'Connell, Michael. *Shadows: An Album of the Irish People 1841-1914.* Dublin: The O'Brien Press in association with Radio Telefis Eireann, 1985.

Philip, Alex. J. *An Index to the Special Collections in Libraries, Museums and Art Galleries (Public, Private and Official) in Great Britain and Ireland.* London, F.G. Brown, 1949.

Reilly, James M. *Care and Identification of 19th-Century Photographic Prints.* (Kodak publication no. G-25.) Rochester, N.Y.: Eastman Kodak Co., 1986.

Rosenblum, Naomi. *A World History of Photography.* New York: Abbeville Press, 1989.

Sexton, Sean, comp. *Ireland in Old Photographs.* A Bulfinch Press Book. Boston: Little, Brown and Company, 1994.

Somerville, E. OE. and Martin Ross. *Wheel-Tracks.* London: Longmans Green, 1923.

Smith, Gus. *Ring Up the Curtain!* Dublin: Celtic Publishers Ltd., [1976?]

Thom's Directory of Ireland. Dublin: various years.

Walker, Brian M., Art Ó Broin & Sean McMahon. *Faces of Ireland 1875-1925.* 2nd ed. Belfast: Appletree Press, 1984.

Who's Who, What's What, and Where in Ireland. A Zircon Book in association with the Irish Times. London: Geoffrey Chapman Publishers, 1973.

Woodbury, Walter E. *The Encyclopaedic Dictionary of Photography: Containing Over 2000 References and 500 Illustrations.* (S. & A. photographic series, no. 45.) New York: The Scovill & Adams Co., 1898.

Woodham-Smith, Cecil. *The Great Hunger: Ireland 1845-1849.* New York: Harper and Row, 1962.

CHRONOLOGICAL ANALYSIS—DECADE COVERAGE

(refers to date of depiction, not date of prints, some of which may have been reprinted more recently)

NOTE: This listing excludes the Copy Negative Collection, Miscellaneous Photograph Collections, Various Albums, Various Negative and Slide due to their broad spans. See individual entries for chronological coverage.

NOTE: Larger (totalling over 1000 images) collections are noted in boldface.

1840-1849
Daguerreotypes, Fox Talbot's *Pencil of Nature*

1850-1859
Chandler, Daguerreotypes, Kilronan Albums

1860-1869
Anderson Album, Blake-Forster, Lord Castletown, **Chandler, Clonbrock,** Coghill, Edgeworth, Fenian Album, Haffield Albums, **Lawrence,** Royal Archives, Smyth, **Stereo Pairs, Wynne**

1870-1879
Anderson Album, Blake-Forster, Lord Castletown, **Chandler, Clonbrock,** Coghill, **Eblana,** Edgeworth, Haffield Albums, **Lawrence,** Royal Archives, Smyth, **Stereo Pairs, Wynne,** *Wynne's Souvenir Scrap Album*

1880-1889
Lord Castletown, **Chandler, Clonbrock,** Coghill, Coolgreany Album, Deane Album, Dillon Album, Duncan, **Eblana,** Edgeworth, Green, Haffield Albums, "Invincibles" Album, **Lawrence, Poole,** Scully, Sheehy Skeffington, Smyth, **Stereo Pairs,** Ternan, Tyers, **Wynne**

1890-1899
Browne's *Ethnography,* Lord Castletown, **Chandler, Clonbrock,** Coghill, Deane Album, Dillon Album, Edgeworth, Green, Haffield Albums, Joly Slide, **Lawrence,** Levingston, O'Connor (Fergus), **Poole,** Scully, Sheehy Skeffington, Spillane, Smyth, Ternan, Tyers, **Westropp Antiquities Albums, Wynne**

1900-1909
Lord Castletown, **Chandler, Clonbrock,** Congested Districts Board, Deane Album, Dillon Album, **Eason,** Edgeworth, Green, Haffield Albums, **Lawrence, Mason,** Mulcahy, O'Connor (Fergus), Panoramic Albums, **Poole,** Scully, Sheehy Skeffington, Smyth, Spillane, Tempest, Ternan, Tyers, **Valentine, Westropp Antiquities Albums, Wynne**

1910-1919
Abbey Theatre, **Chandler, Clonbrock,** Congested Districts Board, Dillon Album,

Eason, Easter Rising and Civil War pamphlets, Edgeworth, Fay, Green, Haffield Albums, Keogh, Kernoff, **Lawrence, Mason,** Mulcahy, O'Brennan, O'Connor (Fergus), O'Neill Album, **Poole,** Price, Scully, Sheehy Skeffington, Smyth, Spillane, Ternan, Tyers, **Valentine,** Waldron, **Westropp Antiquities Albums,** Westropp Easter Rising Album, **Wynne**

1920-1929
Abbey Theatre, Ceannt, **Chandler, Clonbrock,** Dripsey Woolen Mills, **Eason,** Easter Rising and Civil War pamphlets, Edgeworth, Fay, Fitzelle Albums, Green, Haffield Albums, Hogan, Keogh, Kernoff, MacConnoran Album, Mulcahy, O'Brennan, **Poole,** Price, Quane, Scully, Sheehy Skeffington, Stokes, Ternan, Thornton, Tyers, **Valentine,** Waldron, **Westropp Antiquities Albums, Wynne**

1930-1939
Abbey Theatre, Boyne Viaduct Album, Ceannt, **Chandler, Eason,** Edgeworth, Fay, Green, Kernoff, Mulcahy, **O'Dea, Poole,** Quane, Sheehy Skeffington, Stokes, Ternan, Thornton, Tyers, **Valentine,** Waldron, **Wynne**

1940-1949
Abbey Theatre, **Cardall,** Edgeworth, Fay, Green, Healy, Jackson, Kernoff, Kilkenny Architectural, Luftwaffe, Mulcahy, **O'Dea, Poole,** Quane, Stokes, Ternan, Tyers, **Valentine,** Waldron, **Wynne**

1950-1959
Abbey Theatre, **Cardall,** Edgeworth, Healy, Hickey, Hinde Postcard, Horgan, **Morgan Aerial, O'Dea,** Kernoff, Mulcahy, **Poole,** Quane, Stokes, Ternan, Tyers, **Valentine,** Waldron, **Wiltshire**

1960-1969
Abbey Theatre, Edgeworth, Hickey, **Hillery,** Hinde Postcard, **Ireland,** Kernoff, Mulcahy, **O'Dea,** Quane, Stokes, Waldron, **Wiltshire**

1970-1979
Hickey, **Hillery,** Hinde Postcard, **Ireland,** Roelofs, **Wiltshire**

1980-1989
Hickey, **Hillery,** Hughes, **Ireland,** Maul, O'Dowda, Roelofs, Therman

1990-1999
Celbridge Album, Hughes, **Lawrence Photographic Project,** O'Connor (Alan), O'Dowda, Our Own Place Photographic Project, Roelofs, Therman

COLLECTION SIZE, IN ORDER
FROM LARGEST TO SMALLEST

60,000-70,000	A. H. Poole Photograph Collection
40,000-50,000	William Lawrence Photograph Collection
20,000-30,000	Copy Negative Collection
10,000-20,000	Miscellaneous Photographs Collection
5,000-10,000	Wynne Photograph Collection
1,000-5,000	Cardall, Chandler, Clonbrock, Eason, Eblana, Hillery, Ireland (de Courcy Ireland), Lawrence Photographic Project, Mason, Morgan Aerial, O'Dea, Stereo Pairs, Valentine, Westropp Antiquities Albums, Wiltshire
500-1,000	Edgeworth, Haffield, Hinde Postcard, Hughes, O'Connor (Fergus), Our Own Place, Panoramic Albums, Stokes, Ternan
100-500	Abbey Theatre, Blake-Forster, Boyne Viaduct Album, Celbridge Album, Congested Districts Board, Deane Album, Dripsey Woolen Mills, Hickey, Joly Slide, Keogh, Kilkenny Architectural, Mulcahy, O'Brennan, O'Connor (Alan), Roelofs, Sheehy Skeffington, Kilronan Albums, Therman, Thornton, Tyers, Ulster Museum, *Wynne's Souvenir Scrap Album*
under 100 items	Anderson Album, Lord Castletown, Ceannt, Coghill, Coolgreany Album, Daguerreotypes, Dillon Album, Duncan, Browne's *Ethnographic...*, Fay, Fenian Album, Fitzelle Album, Green, Healy, Hogan, "Invincibles" Album, Jackson, Kernoff, Levingston, Luftwaffe, MacConnoran, Maul, O'Dowda, O'Neill Album, Fox Talbot's *Pencil of Nature,* Price, Quane, Royal Archives, Scully, Smyth, Spillane, Tempest, Various Albums, Various Negative and Lantern Slide, Waldron, Westropp Easter Rising Album

INDEX
Subject terms and persons including photographers

Entries in this index guide the researcher to collections containing significant numbers of images on a given topic, or by a certain photographer. The index is by no means exhaustive. Individual images are not indexed. While names of people and places appear in this index, some collections, notably the Lawrence Collection, are too extensive for detailed indexing here. For example, the Lawrence Collection is indexed under "Ireland (All counties)"; the Hickey Collection which contains numerous photographs of actors is indexed under "Actors" and other terms.

Physical formats/genres (e.g., stereographs) are indexed in the separate index following.